M000019463

BEACH MEXICAN

BEACH MEXICAN

ASSIMILATION & IDENTITY
IN REDONDO BEACH

ALEX MORENO AREYAN

Charleston · London

THE
History
PRESS

Published by The History Press
Charleston, SC 29403
www.historypress.net

Copyright © 2013 by Alex Moreno Areyan
All rights reserved

First published 2013

Manufactured in the United States

ISBN 978.1.60949.661.6

Library of Congress CIP data applied for.

Notice: The information in this book is true and complete to the best of our knowledge. It is offered without guarantee on the part of the author or The History Press. The author and The History Press disclaim all liability in connection with the use of this book.

All rights reserved. No part of this book may be reproduced or transmitted in any form whatsoever without prior written permission from the publisher except in the case of brief quotations embodied in critical articles and reviews.

This book is dedicated to my wife, Linda, and my children, Damian, Analisa and Ryan, for insisting I write it; all my family members—past, present and future; and James Michael Areyan. James, I hope this book will help you understand your roots.

CONTENTS

ACKNOWLEDGEMENTS

M y love and gratitude to my beautiful, generous wife, Linda, for her countless hours of moral and editorial support. Her meticulous editing of multiple drafts honed my ideas and played a crucial role in completing this book. Not every writer has the privilege of having an in-house editor. She continues being *mi rayo de luz* (the sunshine of my life).

I am indebted to Carmen Contreras Hernandez, who has allowed me to use her term "Beach Mexican" for the title of this book. I am also grateful that she shared with me her encyclopedic knowledge of the Mexican American history of Redondo Beach and Hermosa Beach.

A very special thank-you to Dr. Francisco Jimenez at Santa Clara University, who provided me with my original inspiration for this book after I read his two moving books: *The Circuit: Stories from the Life of a Migrant Child* and *Breaking Through*.

My heartfelt thanks to my editor, Jerry Roberts, whom I have come to admire and trust for his unfailingly wise and incisive editorial judgment. He has been a calm reservoir of support during every step of this book. Even the title of *Beach Mexican* did not deter him from supporting my story.

Another person who stood by me and offered support in my moments of anxiety is my good friend columnist Don Lechman. Don made me believe in myself and this project, and he continues to support my efforts to be a writer.

An affectionate thank-you to our friends and traveling companions Bob and Maria Boiles and Steve and Joyce Lepore for their good-natured ribbing

and support. Bob is still waiting for me to write a book about old white guys in Aerospace.

This book would not have been possible without the help, generosity and support of the following friends and family: Cindy Aragon; Herminda Banda; Porfiria Banda; Joe Chavez; Robert Flores; Virginia Banda Flores; Alex Flores; Nieves and Calistro Gonzalez; Margie Hart; Pat Havens and Carolyn Valdez Phillips of the Strathearn Museum in Simi Valley, California; Scott Irving Harrison; Sydne Yanko Jongbloed; Albert Juarez; Peter Serrato; Ronnie Serrato; Tere Serrato; Norm and Sally Marshall; Linda Fincham Waite; and Tom Volpi.

I received support and assistance from so many people that it is impossible to mention everyone by name. To those who I may have overlooked—I apologize and assure you that any oversight is unintentional.

INTRODUCTION

My cultural assimilation experience in the South Bay was shaped by what I believe was a number of distinctive factors. Growing up in the 1950s, the Mexican American population of Redondo Beach, California, never exceeded 5 percent of the city's approximate population of forty-five thousand, with the city's core being Anglo-American. Within the section of the city known as North Redondo, the number of Mexican American families was relatively small when compared to the nearby communities of Wilmington and San Pedro, which had much larger Mexican American barrios or neighborhoods. This meant that assimilation of the Mexican American community into the majority Anglo culture was somewhat different. For example, North Redondo's Mexican American section was composed of about sixty families, surrounded by the larger, dominant Anglo community and culture. Because of our smaller numbers, and despite the fact that we had been raised in our parents' Mexican or Mexican American cultures, we had to assimilate into the Anglo culture quickly in order to "fit in." To do this, it became important to rapidly adapt and incorporate the English language and culture into the Spanish language and culture in our formative years and into adulthood.

The dominant Anglo culture created informal yet strong peer and social pressure to conform to the dominant culture. Because the Mexican American neighborhood in North Redondo was much smaller than other places such as East Los Angeles, the assimilation experience was different. My old neighborhood did not have many of the cultural identifiers of a

typical barrio—schools with large Mexican American enrollments, ethnic community halls, clubs or small neighborhood stores with Spanish signage and advertising—that strengthen ethnic ties and identity but sometimes slow assimilation. What North Redondo had was something of an "ethnic scattering" of Mexican American residents. What the neighborhood did have, in many cases, were bilingual parents who, despite knowing two languages, tended to have their children grow up speaking English as their first language. Many children had a working understanding of Spanish but never learned to speak more than a few Spanish words themselves. Some parents would tell their grown children that their insistence on having them speak English exclusively was a way to protect them from the discrimination they had experienced while speaking Spanish at school in their youth. Regrettably, this encouraged an environment wherein only when absolutely necessary would children acknowledge their Mexican heritage. Indeed, they would sometimes claim to be descendants of more culturally acceptable groups such as European Spanish, Spanish/French or other combinations.

In my case, because I am the son of a Mexican immigrant who spoke no English and a first-generation Mexican American mother, I was predisposed to inherit my father's language, values, customs and traditions. For the first five years of my life, I thought and lived in a Spanish-speaking, Mexican American world. It was not until I entered elementary school that the gradual and sometimes awkward process of my assimilation into the dominant American culture began. Prior to elementary school, I needed English only to communicate my needs to the Good Humor ice cream and the Helms Bakery truck drivers who trolled through the old neighborhood.

Originally, the concept of this book centered on describing my early childhood social assimilation experiences up to my high school years. However, in an effort to show that assimilation continues into higher education, I have included a chapter covering this period.

This book chronicles what it was like for a Mexican American male growing up in an area known by local residents as the South Bay—an area generally perceived as middle class and, in some cases, financially affluent. There are exceptions to this perception, however, as will be explained in this book. My assimilation experiences include a distressing eight-year period during elementary school and high school in which I joined my family journeying as migrant workers across the great central valley of California and later in the San Fernando Valley.

This story is my own. It does not pretend to portray the exact experiences of other Mexican Americans in Redondo Beach or any other place.

However, based on a number of interviews with other Mexican American residents—male and female, past and present—who have lived in Redondo Beach over time, many of our experiences are similar. On the other hand, Anglo American friends and neighbors, growing up alongside South Bay Mexican Americans, will disagree or perhaps even deny that the experiences I have described in this book are based on reality. To these friends, especially those with whom I attended high school and beyond, my story may come as a surprise, as I had not openly spoken about many of these events in my life before now. Some may even be inclined to say that I am not describing the person they knew in the past. Still others may say the description of my assimilation journey is embellished or exaggerated. To these friends, I can only say that sometimes one has to walk in the shoes of a Mexican American growing up in the '40s, '50s and beyond to fully understand what I have written. Accordingly, *Beach Mexican* is the story of my odyssey while growing up in a nontraditional neighborhood in a nontraditional way, living and surviving a slightly different variety of assimilation than other Mexican Americans who grew up in much larger barrios.

My journey has included periods of diminished self-confidence, painful ethnic bias, cultural alienation and social exclusion. The survival tools I developed during this journey included exercising cultural self-restraint, persistence, perseverance and determination, coupled with large doses of resiliency, tolerance, forbearance and understanding.

CHAPTER 1

REDONDO BEACH IN THE 1950S

Being a Mexican American from Redondo Beach is something of an oxymoron. As I grew up, when I told Anglo friends living outside Redondo Beach that I was from a beach community, I could almost hear their mental gears turning as they wondered how a Mexican American could be from an affluent beach community. After all, Mexican Americans stereotypically grew up and lived in economically depressed areas. They weren't entirely wrong in their thinking.

Growing up, my hometown was divided into three distinct geographical areas: South Redondo, Central Redondo and North Redondo. South Redondo's residents were predominantly Anglo/white middle-class professionals. Homes there were large and situated on gently rolling lots, located within blocks of the beach and in close proximity to the wealthy Palos Verdes Peninsula.

Central Redondo, near the Redondo Beach pier, was the birthplace of the city, which had been founded at the turn of the century. It had once been the center of the city, where the major businesses and government offices were located before they shifted and expanded to a larger, more suitable location on Pacific Coast Highway, which ran through the heart of the city. Many of its commercial buildings and homes were built from the turn of the century into the early 1920s. Early residents included many city officials and a number of the city's pioneer small business owners, who continued living there until around the late 1950s, when some of the older established businesses moved or closed. This part of the city then lost some

of its residential appeal, and in the late 1950s, some of the older commercial buildings were converted into apartments. Property values remained stable, and the homes in the area were then purchased by growing families. This area of the city was also predominantly Anglo, but around 1930, about twenty Mexican American families relocated there from Lompoc, California, after the closing of a diatomaceous earth mine where many of them had worked. Within a year after the closing of the Lompoc mine, former officials of that mine found new, large diatomaceous deposits on the east side of the Palos Verdes Peninsula. Once the new mine began operations, they rehired many of the displaced workers, who by this time had purchased homes in Central Redondo Beach. These twenty or so Mexican American families differed from those families in North Redondo in that they came to Redondo Beach from Lompoc with enhanced economic and educational backgrounds. In Lompoc, many of the families had worked for the Celite mine for many years and were well established in that city.

When I was born in 1941, North Redondo was sparsely populated and made up primarily of working-class Anglo families—with one exception. I was born in the section of North Redondo that was located about two blocks east of the Hermosa Beach city border. This small neighborhood within North Redondo had twenty Mexican American families living in homes that were closely nestled among the scattered Anglo families. This was the Mexican section of North Redondo. I refer to this area as a section because it was small and measured only about six square blocks. It was not large enough to be called a barrio (a large Mexican American neighborhood), although some residents would sometimes refer to it as "the barrio" or "the Tulies" (Spanish diminutive for eucalyptus trees) for the many trees bordering the neighborhood. Two blocks west of this neighborhood was Nuestra Senora de Guadalupe (Our Lady of Guadalupe) Catholic Church, the spiritual nexus of the community. The homes and land here were far more affordable than in any other part of Redondo Beach. The homes were smaller, wood-sided homes with two or three bedrooms and large yards. This area was home to many empty fields and jackrabbits and dotted with large, unfenced and dangerous wooden oil derricks that youngsters could easily access. Alongside the derricks were flimsily fenced oil overflow basins in which homeowners' goats would sometimes meet their demise. Some of the empty fields in the area were planted with corn for home consumption or for sale to the local grocery stores. The streets were poorly paved, with a scattering of dim streetlights.

Interestingly, most of North Redondo's streets were named after many of America's "Captains of Industry." These names include Rockefeller, Carnegie, Armour, Havemeyer, Morgan, Stanford, Pullman and others and were designated by some of the city's pioneer speculators, who at one time dreamed of attracting large investors who might be lured to the rural north side of Redondo Beach by the important-sounding street names. Their dreams were never realized, however, since ultimately the area attracted only working-class Anglo and Mexican American families. In an ironic twist, South and Central Redondo's streets had Spanish street names such as Gertruda, Guadalupe, Helberta, Irena and Maria, although these areas had the fewest number of Mexican American families living there. These streets were named for the female descendants of the Dominguez family, owners of the original Spanish land grant of the South Bay area, which included the Palos Verdes Peninsula.

CHAPTER 2

I ENTER THE WORLD WITH THE HELP OF ALTAGRACIA

I was born on the floor of a one-room house at 1718 Morgan Lane in north Redondo Beach, California, on July 8, 1941, to Alejo Areyan and Inez Moreno Areyan. I was the youngest of seven children. My given name was Isabel Alex Areyan. I was named Isabel in honor of St. Isabel, as it was the Mexican American custom to name children for the saint on whose feast day they were born. Fortunately, my mother saw that this name was going to be a problem for me among the neighborhood boys, so she called me Alex from the start. Like my brothers (Rudy and Michael) and my sisters (Carmen, Guadalupe, Julia and Mary) before me, I was born at home because my parents could not afford a hospital.

My father, Alejo, came to the United States in 1924 at the age of sixteen from a small village outside of the town of Purepero, Michoacan, Mexico. He came into this country at Columbus, New Mexico, as a stowaway aboard a freight train, accompanied by his eldest brother, Emigdio. My father first settled in a Mexican American barrio in Torrance, California, known as *La Rana* (The Frog). *La Rana* was the stopping point for many Mexican immigrants in the early 1920s due to the barrio's proximity to the dozens of vegetable truck farms in the area, where work was easy to obtain. After a short stay, my uncle Emigdio returned to Mexico, and my father stayed. He met my mother around 1927 while attending a neighborhood *jamaica* (fiesta) at Our Lady of Guadalupe Church in neighboring Hermosa Beach. After marrying my mother in 1929, they moved to Redondo Beach.

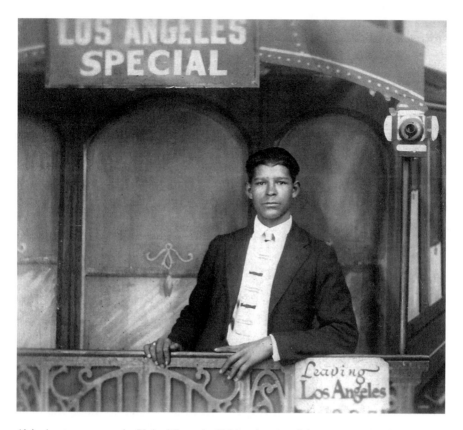

Alejo Areyan came to the United States in 1924 at the age of sixteen to escape the aftermath of the Mexican Revolution. He entered the country in Columbus, New Mexico, aboard a freight train, accompanied by his older brother Emigdio. Alejo later settled in the *La Rana* (The Frog) section of Torrance, California. He married Inez Moreno in 1929 at the beginning of the Great Depression and raised seven children in North Redondo Beach. He is the author's father. *Courtesy of Inez Areyan.*

When I was born, I was delivered by a *curandera* (midwife) named Altagracia, which in Spanish means "high grace." Altagracia lived on Havemeyer Lane, the street behind ours, in a large, old, wood-sided house with windows that were always covered. From her cloistered home, she dispensed plants, herbs and home remedies. On Saturdays and Sundays, cars lined up, several deep, on the dirt shoulder of the street outside her home. In addition to serving the neighborhood's immediate health needs, she also had customers coming to her home from Los Angeles, Compton, Watts and the surrounding Mexican American communities. It was rumored that she practiced magic and for a price would cast and remove

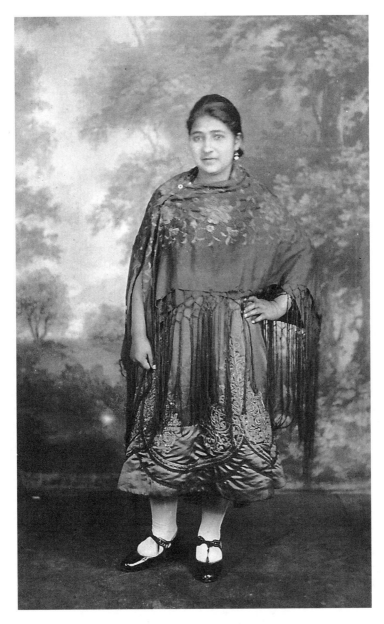

Fifteen-year-old Inez Moreno Areyan posed for this photograph in 1928 before marrying Alejo Areyan in 1929. Inez was the third-eldest of Domingo Moreno's twelve children. She was one of the original child parishioners of the *Nuestra Senora de Guadalupe* church (later renamed Our Lady of Guadalupe) in Hermosa Beach. Before the original church was built, she and her siblings attended catechism classes in Domingo Moreno's old garage. *Courtesy of Alex Moreno Areyan.*

spells. After I was delivered, as was the neighborhood custom, my father paid Altagracia ten dollars for her services.

Later that same day, Dr. Butts or Dr. La France, whose offices were located in Central Redondo, came to my house, checked my mother, completed and signed the certificate of live birth and collected fifty dollars. Their fee was paid in installments. Thus, like most of my brothers and sisters, I was born on credit, as were many of the kids in our neighborhood. Altagracia had a misfortune that occurred during one of her deliveries, as my true eldest brother Luis was delivered stillborn. My mother tearfully told me years later that during a very difficult birth, Luis's umbilical cord had become entangled around his neck, depriving him of oxygen and resulting in his death. At that time, midwives, though unlicensed, were recognized by doctors as bona fide home delivery practitioners. This event was not talked about among family or neighbors and was accepted as a sad and difficult part of life in the old neighborhood.

Life at home in my neighborhood was never easy; money was always a concern. My family was monetarily poor, even compared to the other residents of North Redondo. However, I didn't really become aware that we were poor until I started elementary school. Until then, my life was defined by my neighborhood. Since everyone in my immediate neighborhood looked like me, lived like me or was related to me, it was hard to tell just how poor or different we were compared to Anglo American families. However, in a familial and spiritual sense, we were rich. My parents surrounded us with caring and unspoken affection. Their love was not about showering us with kisses and embraces but was instead contained in the strong bonds of family unity that they created. They molded us into a cohesive family unit, preparing us to face whatever challenges or setbacks life would bring. Their love was silently evident when they provided us with the necessities of life: home-cooked family meals, shelter, clothing and family unity. Their strong, stoic love taught us resiliency and determination, making us stronger. The family bonds that their love created would sustain and support us well in the coming years. They also provided us with a firm grounding in our Catholic faith. My family was raised with a strong belief that God, prayer and faith would always provide answers to any crisis. Their love made us a family.

Because money was a problem, I recall times when it was difficult to keep my brother Mike and me in shoes, causing us to run around barefoot during the summer to save our shoes for the school year. It was not unusual for my resourceful mother to shop at *la segunda* (a second-hand store) for gently used clothing for us to wear. She would often say, "We may be poor, but you kids

will always be clean and look your best." Despite our money worries, we remained a large, close-knit family, bonded by love and respect, with two parents who remained married for forty-seven years.

In the early days after I was born, with seven siblings and my two parents living in our one-room house, meals were simple yet nourishing and consisted of three staples: home-cooked pinto beans, homemade flour tortillas and different types of tomato-based salsa, which we called chili. Since my mother could not afford to shop at a supermarket, she bought her meat, vegetables and fruit from a small van that had been converted to a fresh meat truck by its owner. The truck came through the neighborhood once a week. The vegetables were not always fresh, and the fruit was usually close to being overripe, but the prices made for easy buys for struggling families. The driver, known to everyone as *el marchante* (the merchant), was an older man of Arab heritage. He spoke perfect Spanish and would announce his arrival in the old neighborhood by banging a hammer on an old truck rim on the floor of his truck. He always wore a white bloodstained apron as if he were a real butcher. He had extremely hairy arms and hair growing out of his ears. When my eldest brother Rudy and my cousin Chuey Colin teased him about his hairy ears and told him he should put them on display to sell them as meat, he would draw a long butcher knife from his belt holder and mockingly chase them away from his truck.

Household goods were bought from a Jewel T company truck, which also came through the neighborhood and sold brooms, soap, aprons and a variety of cold and cough remedies. This included a vile-tasting cough syrup called Buckley's, which was so wretched because it contained an ingredient with a smell resembling ammonia. The stuff tasted so bad that it nearly caused me to vomit each time my mother insisted I take it. But she swore by it. And if the medicine carried by the Jewel T truck did not cure our illnesses, my mother would turn to the time-tested home remedies handed down from her mother. Then, if all else failed, there was always Altagracia. The other two vendors that came around were the old Helm's Bakery and the Good Humor ice cream trucks. It was with these drivers that I first began to learn and speak English before beginning elementary school.

My family's first home was a one-room house resembling a big box with a crude basement. My parents, my four sisters and I shared the one large room. Beds lined the walls, and I slept with my parents. My two brothers had a bed in the basement. This was an extremely difficult living arrangement, especially for my parents and sisters, who had no privacy. At this age, I didn't realize we were any different from anyone in the immediate neighborhood,

because everyone around us lived pretty much the same way. At the front of the room was a small kitchen, where I watched my mother every day as she prepared dinner, waiting for my father to arrive from work. Luckily, we had a radio to listen to while my mother prepared dinner. We listened to KWKW, a Los Angeles radio station that played only Mexican music. We sang along to Mariachi and Ranchera songs, sung by artists like Pedro Infante and Jorge Negrete, two of Mexico's greatest singers. I learned to love many of these old songs. As a result, as an adult in the 1990s, I was able to sing along with all of the songs on Mexican American rock singer Linda Ronstadt's album entitled *Canciones de mi Padre* (My Father's Songs). I still enjoy hearing and singing along to the songs I heard on the radio in my mother's little kitchen.

This first house was built by my grandfather Domingo Moreno, on one of the three adjacent lots that he owned. My parents were married in 1929 at the beginning of the Great Depression. A few years later, my grandfather sold the small house and the three lots to my parents, who made payments to my grandfather for many years. The house had running water but no indoor toilet or heating. An outhouse was located on a small rise a safe fifty feet east of the house.

When this first home was razed around 1946, my family moved into a two-bedroom house that had been converted from an old garage on one of the lots. This house had a long, dirt driveway, even though we had no garage. My uncle Nacho Estrada, the family craftsman, who was married to my mother's sister Petra, later helped my father add a roughly constructed room that eventually became a much-needed third bedroom for me and my brothers. This house was larger and had running water, but we were still using the old outhouse. The only source of heat was provided by the kitchen stove. Hot water for Saturday baths came from two large tubs of water that were heated behind the house. My brothers, sisters and I took turns stoking the fire under the tubs to heat the water. Baths were taken in a screened-in porch at the front of the house. Buckets of hot water needed to be carried from the fire at the back of the house up two steps to the porch in the front. This was a Saturday routine for my siblings and me. Even though I was the youngest, I was expected to help. For my sisters' privacy, white sheets were tacked to the porch ceiling to hide the wash and rinse tubs.

We were living in this second house when, in 1952, my parents bought our third house from the State of California with money we had saved from our migrant farmworker earnings. This house was one of many sold by the state to make room for the San Fernando portion of the San Diego Freeway. The homes were sold at auction at a fraction of their value with the condition that

they be moved away quickly after the auction. Fortunately, when my parents bought the first house from my grandfather, it included two adjacent lots. Since our second house was located at the back end of the middle lot, there was enough space to have the newly purchased home moved and placed on a new foundation in front of the second house. Between 1952 and 1955, the front house was slowly remodeled with earnings from our walnut picking in Simi Valley, again with the invaluable aid of Uncle Nacho Estrada, who temporarily connected the old plumbing in the front house. We continued to live in the old house until 1955, but at least we could use the indoor toilet in the front house, and we began feeling more like a normal family.

THE MORENO FAMILY AND THE MEXICAN 500

In the old neighborhood, my mother's family, the Morenos, was huge. My mother was one of twelve children born to Domingo Moreno and Maria Bravo Moreno. There were seven daughters and five sons. When my aunts and uncles married, I eventually inherited a total of twenty-two aunts and uncles, who produced forty-eight first cousins. When you add the seven Areyan children, Domingo and Maria had fifty-five grandchildren, nearly all of them living close by. In addition to my mother's immediate family, I was connected through her to the Colin family, as her mother, Maria Bravo Moreno, and Catarina Bravo Colin were sisters. The two sisters and their husbands, Domingo and Mauricio, arrived in Los Angeles together around 1905 to escape the turbulence of the Mexican Revolution.

The Colin family had thirteen children, who were my mother's first cousins. When all the Colin sons and daughters married, they became twenty-six. These Colin cousins had a total of sixty-five children, who are my second cousins. Confusing? Yes. Suffice it to say that I eventually had almost 150 relatives living within blocks of one another in my neighborhood. This made our two families the largest family group of Mexican Americans in the entire city. Today, the combined Moreno and Colin families, along with their descendants, number around 500 people. I lovingly call them the "Mexican 500."

Both families attended Our Lady of Guadalupe Catholic Church in Hermosa Beach, two blocks west of my neighborhood. The church was built in 1921 by my grandfather, Domingo Moreno; Mauricio Colin; and about

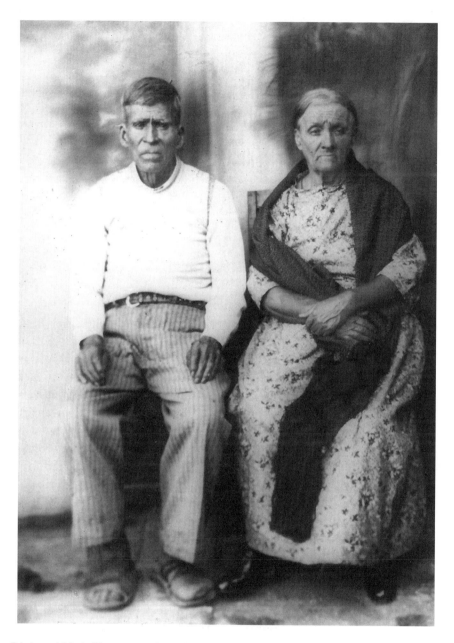

Iginio and Maria Vasquez are shown in this circa 1900 image, which was taken in Mexico around the time of the Mexican Revolution. Their only son, Domingo Moreno, came to Los Angeles around 1905 and lived near old Olvera Street. In 1915, he settled in Redondo Beach, where he and his wife, Maria, raised twelve children. Some of his children were baptized at the old Olvera Street church. These are the author's maternal great-grandparents. *Courtesy of Inez Areyan.*

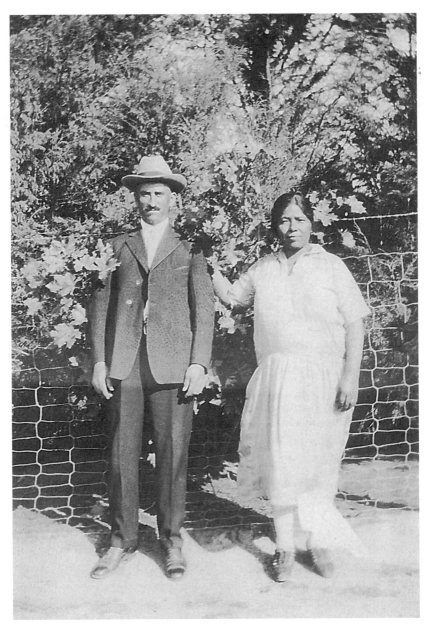

This circa 1912 image shows Domingo Moreno and his wife, Maria, at their first home in the United States near old Olvera Street in downtown Los Angeles. Domingo and Maria traveled from Morelia, Michoacán, in 1905, accompanied by her sister, Catarina Bravo Colin, and her husband, Mauricio. *Courtesy of Inez Areyan.*

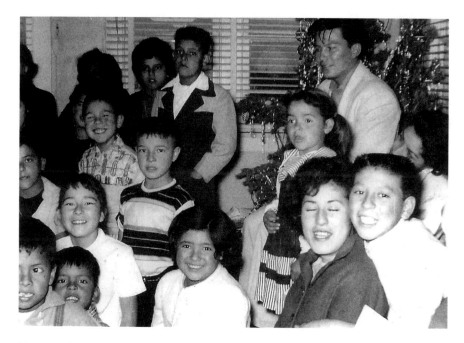

Twelve of Domingo Moreno's fifty-five grandchildren are depicted at the annual Christmas gift exchange, which lasted all day. Domingo proudly presided over the event from his rocking chair in the corner of the living room. *Courtesy of Inez Areyan.*

twelve other weekend volunteers from the neighborhood. The original floor beams of the church were made from discarded lumber from ships in nearby San Pedro Harbor and were transported to the church site by horse-and-wagon teams. Before the small mission church was built, the land had been used for horse stables by Mrs. Dewey and Mrs. McDonald. Our Lady of Guadalupe church records show that Mrs. Dewey and Mrs. McDonald saw the Moreno and Colin children playing in a field near the stables and asked them if they ever attended church. They replied that the only church they had attended was the *placita* (small plaza) church at Olvera Street in downtown Los Angeles before their families moved to Redondo Beach. Recognizing that the Moreno and Colin children had no place to attend classes to prepare them for the Catholic sacraments, Mrs. Dewey and other parishioners from St. James Catholic Church in Central Redondo donated the land for construction of the original small mission church. Meanwhile, until the church was built, Mrs. Dewey transported the children to St. James in her old Ford Model-A automobile, sometimes having them ride outside on the running boards.

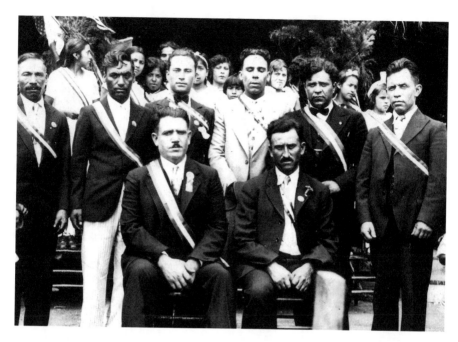

Around 1923, Mexican American community leaders formed *El Club Morelos* (The Morelos Club) at the *Nuestra Senora de Guadalupe* church in Hermosa Beach, California. This image, taken around 1933, shows members commemorating Mexico's independence from Spain at Clark Stadium in Hermosa Beach. *First row, left to right*: Alfredo Flores and Domingo Moreno (president). *Second row, left to right*: Mauricio Colin, Victoriano Gomez, Jesus Camarena, unidentified, Alfonso Limon and Romauldo Saldana. *Courtesy of John Luna Moreno.*

From the early 1920s until 1958, when the new church was built, hundreds of weddings, funerals and festivals were celebrated in the small mission church, bringing together many Mexican American families. The small church became the spiritual center of our neighborhood and the closest thing the community had to a social gathering place. As a result, today there are many family connections between Mexican Americans in Redondo Beach, Hermosa Beach, Torrance, Gardena, Carson and San Pedro that had their beginnings at Our Lady of Guadalupe Church. As one of the children for whom this church was built, my devoutly Catholic mother attended countless Masses and neighborhood funerals there and sought comfort and solace praying her rosary in the church during difficult times throughout her life. She also brought families together after funerals to pray *novenas* (nine days of prayers) that would accompany the souls of the deceased on their journey to paradise.

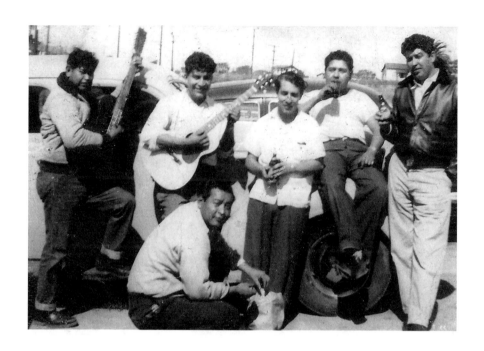

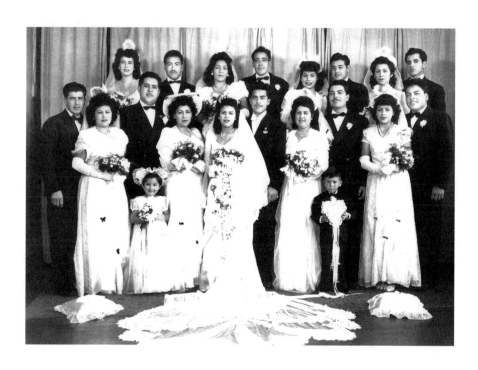

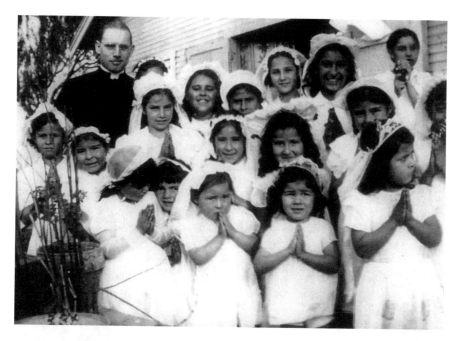

Above: Seventeen young girls celebrate their First Communion sacrament at Our Lady of Guadalupe church in Hermosa Beach in this circa 1949 image. The families represented in this image are Areyan, Estrada, Cortez, Leon, Moreno, Ortiz, Ruiz and Savedra. Father Cyril Wood spoke fluent Spanish and was beloved by all parishioners. He served the church from approximately 1942 to 1949. *Courtesy of Herminda Banda.*

Opposite, top: North Redondo Beach, circa 1940. Typical young men in the Mexican American section of the city sharing music, friendship and weekend libations. *Courtesy of Luis "Luigi" Moreno.*

Opposite, bottom: The 1947 wedding of Trinidad "Trino" Banda and Porfiria Moreno was cause for celebration and brought together Mexican American families from Redondo Beach, Riverside and Torrance. Weddings were important social events that forged lifelong bonds between families. The wedding took place at *Nuestra Senora De Guadalupe* church in Hermosa Beach. Trinidad had just returned from military duty in World War II. The flower girl is Roberta Moreno. The ring bearer is the author. *Courtesy of Inez Areyan.*

My mother's devotion to praying the rosary was influenced by Frances "Panchita" Vail, an icon and early pioneer of Our Lady of Guadalupe church. She was a close friend and contemporary of my grandfather, Domingo Moreno, and she helped establish the original church in the early 1920s. Panchita's knowledge and beautiful recital of the rosary was without equal. Her command of every intricate element of the rosary mesmerized those who were fortunate enough to hear her pray, including myself. As a young

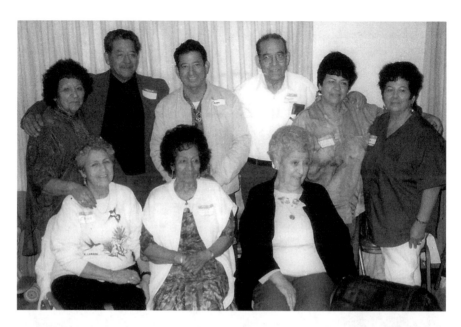

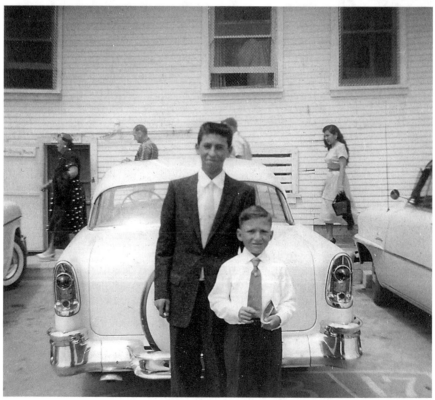

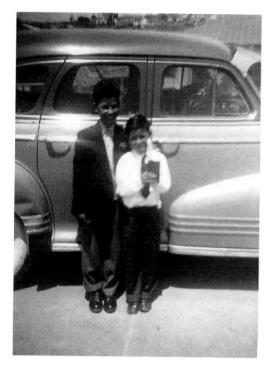

altar boy, when Panchita prayed an evening rosary for a deceased parishioner, I was fascinated with the poetry of her prayers.

My mother insisted that my brother Michael and I serve the church as altar boys when we turned seven years old. I was an altar boy for eight years. One eerie thing I remember about helping the priests with funerals at the old church was riding to the cemetery in the front seat of the hearse with Father Gargallo and the driver. During these years as an altar server, I became familiar with the names of hundreds of parish members. This would be extremely useful to me in 2007, some fifty years later, when I authored a book documenting the more-than-one-hundred-year history of Mexican Americans in Redondo Beach and Hermosa Beach.

Above: The sacrament of First Communion was an important religious event in the young life of the author. This 1950 image shows Michael Areyan (left) and the author holding his catechism book and candle, symbols of achieving First Communion. This image was taken at the home of the author's grandfather, Domingo Moreno. *Courtesy of Inez Areyan.*

Opposite, top: Nine of Domingo Moreno's twelve sons and daughters are featured in this circa 1975 image. *First row, left to right*: Irene Savedra, Anita Savedra and Inez Areyan. *Second row, left to right*: Juanita "Jenny" Chavez Ortega, Vincent "Chente" Moreno, Isaias Moreno, Gonzalo Moreno, Porfiria Banda and Aurora "Dora" Segoviano. Missing are Francisco "Frank" Moreno, Petra "Aunt Pete" Estrada and the youngest son, Bonifacio "Boni" Moreno. *Courtesy of Inez Areyan.*

Opposite, bottom: This 1957 image shows Hendry Felix, joined by his godfather and the author, posing after his First Communion at the *Nuestra Senora de Guadalupe* church in Hermosa Beach. The door to the left rear served as the entrance to the small kitchen in the basement, which also doubled as a boxing ring that had been set up by Father Wood around 1950. *Courtesy of Alice Buffington.*

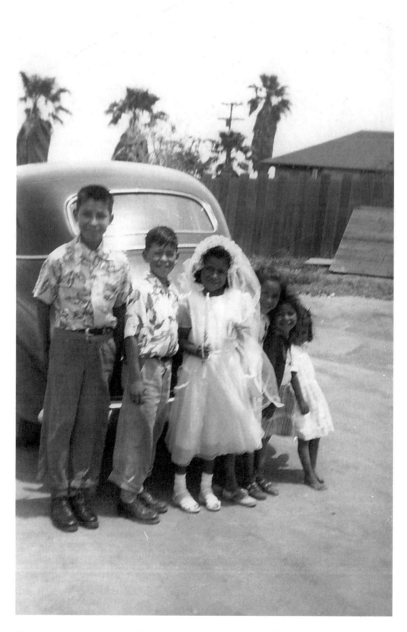

Esperanza Arenas's First Communion dress is admired by her five cousins in this 1951 photo. *From left to right*: Michael Areyan, the author, Esperanza, Dolores Aguilar, Luisa Palomares and Julie Arenas. Note the dirt driveway of the author's home.

As a child, my social life largely consisted of visiting my uncles, aunts, cousins and other relatives in the neighborhood. Attending family and neighborhood events such as baptisms, wedding showers and wedding receptions was cause for much celebration and was an important part of my social upbringing. These were community events that parents, kids, friends, and everyone else attended. In the case of baptisms, parents of the child being baptized carefully chose a couple to be the child's *padrinos* (godparents). The two couples then became *compadres* (co-parents). The joining of the two couples through the sacrament of baptism created a special lifelong bond among the child, his parents and the godparents that was considered to be sacred and unbreakable. In the old Mexican Catholic tradition, the role of the godparents was vital because if the child's parents died during his or her infancy, the godparents were expected raise the child and ensure that he or she was brought up in the Catholic faith.

MY FIRST ENCOUNTER WITH ASSIMILATION: BERYL HEIGHTS ELEMENTARY SCHOOL

Until I started elementary school, my early years in the old neighborhood were relatively worry-free. That would change when I entered first grade at Beryl Heights Elementary School.

From first to sixth grade at Beryl Heights, I felt out of place and uncomfortable among my classmates. I felt different from the other kids for several reasons. Before first grade, my neighborhood and my life were filled with people with brown skin, brown eyes and black hair who looked like me and spoke Spanish. At Beryl Heights, I was this little brown Mexican kid who looked different and had a different-sounding name. No one at Beryl Heights was named Alex, and no one had a last name like Areyan. I remember not liking my first name and wondering what it would be like to have a common name that was easy to say and pronounce like Jimmy or Larry. Even though Spanish was my first language, and even if I found a classmate who looked like me and possibly spoke Spanish, I dared not speak Spanish to him or her for fear that the other kids would see me as being different, which would most likely result in my being teased or bullied.

At the beginning of every school year, the other kids always wore new clothes and different pairs of shoes during the week. When it rained, they wore rubber galoshes, which I had never seen until I started school. Throughout the school year, they seemed to always wear new clothes, and during the winter, they wore fancy winter coats and jackets. My clothes, on the other hand, were not always new, and I had only one pair of shoes to

wear—even when it rained. Many of my clothes were hand-me-downs from my brother Michael.

My lunches consisted of homemade burritos wrapped in washable cloth napkins, always packed in a brown paper bag, which on a good day also contained one piece of fruit. My classmates, on the other hand, had brightly decorated metal lunch pails featuring cartoon characters on the lids. Their lunches contained lunchmeat or peanut butter and jelly sandwiches, chips, a thermos filled with milk and always a sweet treat. At lunchtime, our food was placed on the high wooden steps behind the auditorium, and the kids would come and go, alternately eating and playing. During lunch, I would stay on the steps to avoid exposing my burritos. Thankfully, in third grade, my mother stopped packing burritos in my lunch, probably remembering her childhood experiences at Grant School, where kids sometimes tossed dirt on her burritos, forcing her and her siblings to eat their lunches in the restroom in order to escape the bullying of the Anglo kids. The potted meat or peanut butter and jelly sandwiches that now replaced my burritos brought me a step closer to feeling like I fit in.

At Beryl Heights, I also felt different and out of place with the other kids because my parents never attended PTA meetings or parent-teacher conferences. But they had their reasons for not attending, one of which was that a prevalent Mexican American cultural value at the time held that teachers, like other people in positions of authority, were not to be interfered with or questioned by parents in any way. Teachers had far more education, experience and knowledge than parents, and they knew best what kids needed to do to succeed in school. In addition, my father spoke only Spanish and didn't read or write. My mother, who spoke Spanish and English, had only completed fifth grade. They would have had difficulty communicating with the Anglo middle-class parents, with whom they had little in common. I felt bad about my parents never participating in school events, and it increased my sense of alienation from my classmates, even though I tried to understand their reasons for not attending.

I didn't develop friendships with my classmates by hanging out with them after school, as I lived too far away from school, in a different neighborhood. Although I could always count on my neighborhood friends for the fun of a good dirt-clod fight or digging tunnels in the empty fields near home, it wasn't the same. Neighborhood play did a lot for my neighborhood socialization, but it did not help my assimilation with other kids at school. Another condition that hindered my assimilation was that I couldn't ride the bus to school, as school rules stated that I lived too close to the school to ride

the bus. This eliminated the possibility of morning and afternoon banter with kids who rode the bus to and from school. As a result, my friendships were all in my neighborhood, which meant I had to count entirely on my neighborhood friends for afterschool activities.

Possibly the biggest factor that slowed my social integration and caused me embarrassment was the fact that if I invited classmates to my house, they would naturally compare their housing and neighborhood with mine. My classmates lived in newly constructed, three-bedroom stucco homes with detached two-car garages. In most cases, their families numbered three to five people. Their yards were professionally landscaped, and their wide sidewalks and streets were perfect for riding bikes and scooters. My house was an older, unpainted, wood-sided house with a dirt driveway and no garage. Nine people lived in our three-bedroom house, and we had no landscaping. Our streets were mostly hills, with only partially paved streets and no sidewalks. Even if I wanted to invite a classmate to my house to visit, how could I explain that we still had an outhouse? Or how would I explain my embarrassing secret of disappearing from school between September and December every year to pick crops? In the end, it was easier to have friends in the neighborhood—friends who didn't ask me questions and who knew and understood my family's circumstances.

On the plus side of my school experience, I was a strong reader and an even better speller. When it came to math, I was fine until Mrs. Hannah started explaining fractions. I understood how two halves of a pie or a tortilla equaled a whole. However, when she tried explaining that three thirds also equaled a whole, I couldn't remember ever cutting a tortilla into three equal parts before eating it and having it then become whole again. This made no sense to me. My happiest moment came in sixth grade, when I was recognized as the school's spelling bee champion. This was my only claim to fame during my years at Beryl Heights Elementary School. My prize was a giant, multicolored pinwheel sucker. Joe Adams, one of my classmates who lived in one of the houses I've described above, asked for a piece of my sucker. I think this was the first time I had ever said no to a classmate. Winning that spelling bee was my biggest achievement in elementary school, and my sucker was not something I was willing to share.

When I finished sixth grade at Beryl Heights School, I still didn't feel like I quite fit in socially or economically with my classmates. I felt like I was a member of a social and economic underclass. I couldn't understand how everyone at school had so much and I had so little. I felt like I was caught up in a set of personal circumstances that I couldn't control or

change. This brought me feelings of isolation and degrees of resentment, making me feel like an outsider, insignificant and powerless to change my condition. My unconscious response to these conditions was to develop a set of defensive and protective mechanisms, including acting out and developing a chip on my shoulder. This behavior was to manifest itself more fully at Hillcrest Junior High School and, later, to some degree at Redondo Union High School.

LAS PISCAS (THE PICKINGS): MY LIFE AS A MIGRANT FARMWORKER

In 1947, my family began an unforgettably painful and personally humiliating experience as migrant farmworkers, harvesting crops in California's massive San Joaquin and, later, Simi Valleys to support our family. For several months each year, we would travel many miles, crisscrossing the five-hundred-mile-long San Joaquin Valley searching for work. These unfortunate experiences would endure for eight years, ending in 1955, when I returned to Redondo Union High School as a freshman. This would greatly affect the rate of my social and personal assimilation into the dominant Anglo culture of my hometown.

My migrant farmworker experience began during the summer of 1947, after my father and my eldest brother, Rudy, lost their factory jobs at the Malleable Pipe Company, where they had worked for about one year. My father had gotten this job with my brother's help, since my father spoke no English, didn't read or write and had only limited work skills. My brother was a machine operator, and my father's job was sorting dirty, oily pipes after threading. I remember the day when I heard my mother crying softly after my father had told her that both he and my brother had been laid off. My mother asked, "What will we do now to support our family?" My father replied that he had been told by friends that by picking crops with a family our size, we could work together to produce a larger income to benefit the entire family. For several days, my parents and Rudy talked about what we would do. Our options were extremely limited. Picking crops was not something new on my mother's

side of the family, since in her childhood, my grandfather and his twelve children had also picked crops. Within a week, it was decided that, with nine mouths to feed and nine family members able to do farm work, the only viable option was to join the migrant farmworker stream traveling up and down the central San Joaquin Valley. We would go north that year, not knowing what we would face.

In September, we left our North Redondo home, traveling over 500 miles to the northern end of the San Joaquin Valley. We would journey every year from 1947 to 1955 to pick crops. We would leave Redondo Beach each September after being enrolled in school for only a short time and would return just before Christmas. Even though my grandparents had picked crops, they had traveled only to Nipomo, about 150 miles north of Los Angeles, and Whittier, which was only about 30 miles east of Redondo Beach. No one had ever traveled 500 miles north. As a result, my parents started these trips full of anxiety and fear of the unknown, having no prior knowledge of what potential hardships the family might face.

Our first stop would be in Castaic, at the northern end of the San Fernando Valley, about fifty miles from Redondo Beach. After Castaic, we would begin the long trek of driving over a treacherous stretch of highway known as the "Grapevine." The feelings of fear and apprehension were repeated each year as we drove over the Grapevine on the way to the fields, and the nightmare repeated itself on each return trip home. The Grapevine at that time was a dangerous, narrow, unlit, two-lane road that rose steadily uphill for thirty-six miles from Castaic to the summit at Gorman, with an elevation of over 3,500 feet. The road snaked through 697 curves to reach the summit. In the 1930s and into the late 1940s, it was the only truck route from Los Angeles to Bakersfield. On this road, loaded semi trucks and passenger cars were frequently involved in accidents along the stretches of winding unlit road, often causing vehicles to go over the side, plunging hundreds of feet down cliffs and resulting in fatalities. To combat our dread and fear, I distinctly remember my mother leading us in praying the rosary from the front seat each time we traveled through the twists and turns of this unforgettable road.

We traveled this road in an aging six-cylinder 1941 Plymouth sedan with used tires and questionable brakes. The back seat had been removed and replaced with a large mattress on which my siblings and I traveled. The underpowered Plymouth pulled an old, wooden trailer piled high with all our household goods and a spare tire. Mechanical breakdowns were a constant fear, since

my father knew little about auto mechanics. Our lunches and dinners on the road consisted of my mother's homemade burritos or, when we could afford it, plain bologna sandwiches. Had we been of Anglo heritage, we could have been mistaken for Dust Bowl refugees.

The trip to the northernmost part of the San Joaquin Valley took us about three days because my father would not push the old Plymouth over forty-five miles per hour. The trip was made slower by gas, rest and bathroom stops, which were often behind trees on the roadside. This was especially difficult for my mother and teenage sisters. We crossed the Grapevine in late afternoon or at night to avoid overheating the car. In case of an emergency, my father would use the water from two canvas-covered water canteens hanging from the front bumper. Regardless of the time of day, the air always smelled of diesel exhaust and burning brake lining on trucks that frequently caught fire. After leaving the summit, the Grapevine rapidly wound down a long, steep hill about ten miles to the bottom.

From there, California's Highway 99 continued north to Bakersfield, about 30 miles away. In the late 1940s, this was the only viable road linking Los Angeles to Bakersfield. In later years, the Grapevine was greatly improved and renamed Highway 99 Alternate. Highway 99, north from Bakersfield, connected the hundreds of fruit and vegetable farms dotting the highway along the 500-mile-long San Joaquin Valley floor. Along the way, the nine of us would all sleep inside the old Plymouth sedan at night, as we had no money for lodging. Our first experience in a work camp would be in the plum and peach orchards in Meridian, Marysville and Yuba City.

MERIDIAN, MARYSVILLE AND YUBA CITY

On several of our trips to Meridian and Marysville, we connected with my Savedra cousins, whose mother was my mother's sister, Anita. Anita and her husband, Transito, had six children. Another of my mother's sisters, Porfiria, and her husband, Trinidad "Trino" Banda, and their children also joined us, as did Uncle Trino's parents, Santiago and Petra Banda, and their eleven children. The three families traveled to Meridian separately, but we would sometimes all work together, moving from orchard to orchard seeking work. Uncle Transito was more assertive than many of the men in any of

the work camps, and he would often venture out looking for the next ranch or camp where we could work.

Plums and peaches were the main crops in Meridian and Marysville. Picking plums was backbreaking, dangerous work for the men. After climbing into the trees, they balanced on the stronger branches while striking the surrounding branches with three-foot-long rubber-tipped mallets resembling baseball bats. Swinging these mallets always presented a danger of falling, risking sprains or even broken bones if one fell awkwardly. After beating the branches to release the fruit, the men would join the rest of the family on the ground, stooping or kneeling in a fan-like pattern around the entire tree and putting the fruit into five-gallon paint cans, which weighed about twenty-five pounds when full. The cans were then carried to the side of the dusty dirt road and dumped into large wooden boxes for pickup. One of the menacing problems of picking plums was that the plums always drew buzzing fruit flies, bees and wasps. Biting insects were an all-day problem. At night, droves of mosquitoes breeding in the Sacramento River would invade the camp, making it impossible to avoid bites that often resulted in skin infections.

Peach picking presented other problems. Peaches were hand picked and placed into heavy canvas bags that you would carry by draping across your chest and over your shoulder. Each picker would have a heavy, ten-foot-high wooden ladder that he or she would have to move around the tree while picking the fruit. Peaches could not be picked in short-sleeved shirts. Long sleeves were a necessity to prevent peach fuzz and unknown pesticides from sticking to sweaty arms. Despite the long sleeves, the fuzz and pesticides would still penetrate clothing, creating a scratching cycle and causing skin rashes on the arms, neck and chest. The same buzzing and biting insects were also present in the peach orchards.

Opposite, top: Zoller's grocery store in Meridian, circa 1988. This long-abandoned store was perhaps the only establishment selling groceries on credit to farmworkers in the late 1940s. This image shows Albert Banda revisiting the old store where his parents, Trinidad and Porfiria Banda, and the Areyan family used to shop some forty years earlier. Albert is the author's cousin. *Courtesy of Porfiria Banda.*

Opposite, bottom: The Meridian Supply Company in Meridian provided the harvesting machinery, fertilizers and chemicals and other agricultural products to ranchers in the late 1940s. This circa 1988 image shows the company still operating. *Courtesy of Porfiria Banda.*

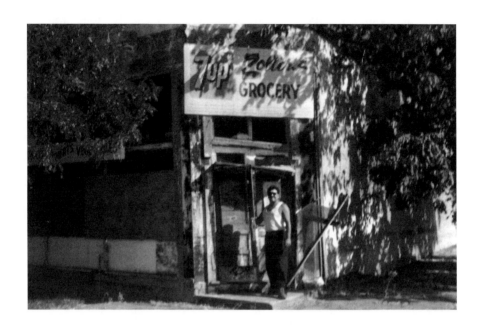

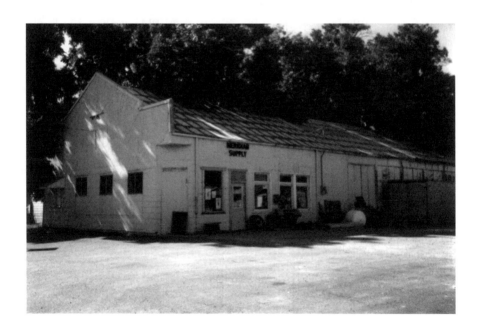

The labor camps in Meridian and Marysville were located right next to the earthen levee on the bank of the Sacramento River. The only barrier between our camps and the river was a dirt berm about twenty feet above the camp floor. As a youngster, I remember lying on my canvas cot at night and fearing that while we were sleeping the river might overrun its banks and drown my entire family. This was a possibility during heavy fall rains. All the families in the camp lived in World War II war surplus canvas tents that smelled of an unknown waterproof coating. Many of the tents had packed dirt floors. The few lucky families who arrived at the camp before us had raised wood floors. The tents came with old wooden army cots and no mattresses. My parents' bed was made up of a series of empty plum boxes arranged in a rectangle, covered by wooden planks and padded with blankets. During hot October days and evenings, the heat and humidity in the tents was unbearable. In the evenings, we remained outside until nightfall to escape the heat of the oven-like canvas tent. After dark, we would enter the tent, fighting off the ever-present mosquitoes while trying to sleep. For me, Marysville and Meridian still hold many sad memories.

Being so far away from home and in such a different environment, I was homesick. At home, even if we didn't have money, we could at least go to the beach. In the orchards, the average temperature in September and October hovered around ninety degrees. The only escape from the heat was going to a nearby bridge to cool off, but we could go there only when there was no work. Work always came first. One late afternoon, a group from the camp went to the bridge to escape the heat by wading in the water near the riverbank. Everyone stayed close to the water's edge because no one knew how to swim. Standing on the bank of the river, I slipped on the edge and went under the water. When I surfaced, I found myself drifting away from the bank and heading down the river. Luckily, my eldest brother, Rudy, who couldn't swim, jumped in and somehow pulled me toward an old fallen tree, where friends helped pull us out. Unquestionably, he saved my life. Today, I live with that memory, and I am still fearful of crossing bridges and being near bodies of water.

Another sad memory I carry involves my sister Lupe, my fair-skinned, reddish-haired second oldest sister. One night in the Marysville camp, Lupe awoke to find that she had been bitten on her arms and legs dozens of times by mosquitoes. This caused her to scratch the bites as she tried to sleep. In a matter of two days, the scratching caused massive infections on her legs, causing them to swell to twice their normal size. Without any available medical care, my mother went to the adjacent town of Yuba City to buy plants and

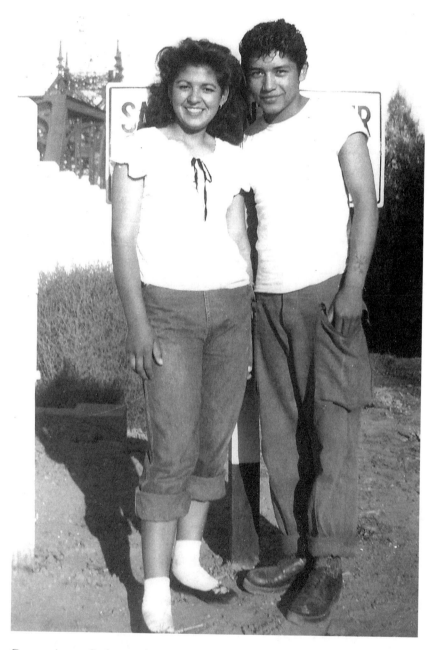

Carmen Areyan Soriano posing at the entrance to a bridge on the banks of the Sacramento River with a friend in Meridian, circa 1947. The Areyan family picked plums and peaches in orchards across the river from 1947 to 1949. The river functioned as a de facto swimming pool, in which the author nearly drowned before being rescued by his older brother Rudy. *Courtesy of Inez Areyan.*

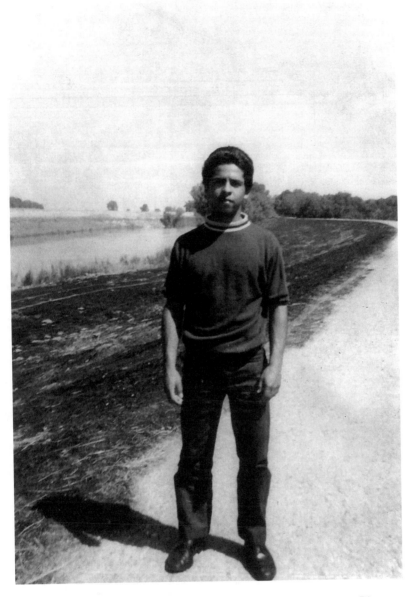

Bobby Banda, the author's cousin, stands on the levee of the Sacramento River near Meridian and Yuba City while retracing his parents' farmworker journey of the late 1940s, when they joined the Areyan family picking plums and peaches. Note the dark high-water line on Bobby's right. If the river overflowed during winter months, the families living on the right side of this levee were endangered. *Courtesy of Porfiria Banda.*

herbs, from which she made compresses to control the swelling and infection. Lupe was not able to work for about two weeks.

Disaster struck us again in Meridian when my sister Julia was severely hurt. Customarily, one of my sisters would leave the field early and return to camp to get a head start on cooking the family's dinner. Our outdoor stove was a fifty-gallon oil drum that had been cut down to a height of about thirty inches and inverted so that the concave bottom of the drum became the cook top. Firewood was fed through an arched hole cut into the bottom side of the drum. One afternoon, Julia was preparing meat in a frying pan on the cook top. My brother Michael was clowning around near the cook top and accidentally tipped the frying pan full of hot oil onto my sister's thigh, causing excruciatingly painful third-degree burns. Again with no medical services available, my mother could treat the large burn only with homemade compresses, miraculously preventing a potentially life-threatening infection. Julia was unable to work for weeks. Luckily, my mother had the gift of a near-encyclopedic knowledge of plants, herbs and holistic home remedies she had learned from her mother, and she used them to treat and cure all of us during our many perilous years of migrant farm work. She was our nurse, doctor and healer during this and all subsequent seasons. After returning to school from that picking season, and during the rest of her high school years, Julia was exempted from wearing gym shorts in her physical education class. In retrospect, we literally lived like the fictional Joad family in John Steinbeck's epic novel *The Grapes of Wrath*, which I read many years later in college.

During another season, we left Meridian after the harvest there and went to Yuba City, an adjacent town, looking for more work. This time we traveled with the Mendivil family from Pomona, California. We had no work, and at night, with no place to stay, both families slept under the Mendivils' large flatbed truck after having draped the sides of the truck bed with sections of canvas for protection. After two nights like this, with no prospects for work in the area, the families decided to go their separate ways. I had never slept under a truck before.

Our only source of information for finding new work was comments made by workers in our previous camp, which was not always current or reliable but was all we had. When we left the Mendivils in Yuba City, we went south about fifty miles toward a labor camp where we believed we could find more work. Before reaching that camp, however, the old Plymouth broke down on a narrow country road. My father was able to maneuver the car into a shallow trench alongside the road. Having no way to fix the problem

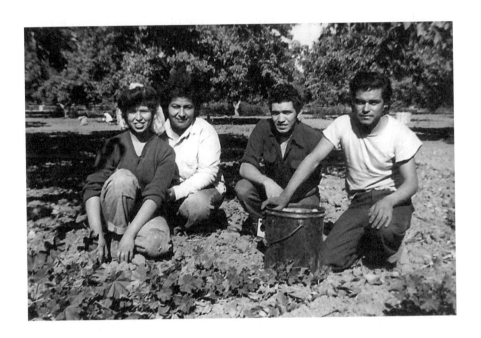

Above: A plum orchard in Meridian or Marysville, circa 1988. Trucks moving between the rows of finely plowed ground raised dust that impaired breathing and settled on clothing, hair and food. Some workers wore bandannas to cover their faces while picking. Typical afternoon temperatures exceeded ninety degrees. *Courtesy of Virginia Flores.*

Opposite, top: Plum picking in Meridian, circa 1948. Lupe Areyan Garza, Inez Areyan and two unidentified workers harvest plums on a hot fall afternoon. The fruit was picked by stooping from the waist down, squatting on your haunches or traveling on your knees around the trees. Fruit was collected in five-gallon paint cans and deposited into wooden crates by the roadside. Fruit flies and dust were ever-present, and nighttime would bring treacherous mosquitoes. Note the children picking over Lupe's right shoulder. *Courtesy of Inez Areyan.*

Opposite, bottom: Virginia Banda Flores and her son Alex in their Torrance home, 2012. Virginia is the youngest of the large Banda family from the *La Rana* section of Torrance and picked crops in Meridian together with the author in their youth. *Courtesy of Alex Moreno Areyan.*

himself, he talked with my mother and older brother about what to do next. I remember my mother saying that we had only about fifty dollars, which we needed for food and gasoline, and that we had no other money to use for car repairs. My father and eldest brother, Rudy, set out on foot, hoping to find a garage that would repair the car while the rest of the family waited in the car on the side of the road. It was almost dark when my father returned. He told us we would have to wait until the next day before a mechanic could drive out to inspect the car. That night, some of us slept inside the car, while others slept outside on a mattress next to the car in the trench. When the

mechanic arrived the following morning, he said that the problem could not be fixed on the spot and that our car would have to be towed to the garage. The repairs would cost nearly fifty dollars, wiping out any cash my mother had saved.

This unforeseen crisis demanded an immediate response. After the car was towed, my mother walked across the road to a plum orchard to ask if they had work. We were very lucky. The owners needed a family to work for about two weeks and asked us to return as soon as the car was repaired. Two days later, we drove into the small farm. Here, they had a small, one-bedroom house for us with a small kitchen, an unfinished plank floor and a wood-burning stove. At least we were not living in a tent. This house had an indoor sink with a cold-water faucet. By the looks of the place, it had not been occupied for several seasons. We would soon learn that this was indeed the case. As my mother began cleaning the house, she ran out of the house screaming, telling us not to enter. Hanging from the ceiling were black bats she had disturbed when she entered. She managed to prop the rickety screen door open and bravely entered again, chasing the bats out of the house with a broom. She would not let anyone enter until she was sure that the bats had all been cleared out. I doubt she even considered the potential danger of being bitten by a rabid bat as she swept the place out.

The next day, as we were settling in, my sisters Julia and Mary spotted a large pear tree loaded with ripe fruit in a fenced area across the street. My sisters told my brother Michael and me that we could join them, and we were excited about picking something new and eating something besides boring plums. The pear tree beckoned us as if it were a candy store. The pears were free—or so we thought. We crossed the road, entering into a large, fenced pasture in which cows were grazing in the distance. The pear tree was located about fifty feet inside the fenced pasture. We climbed easily through the fence, crossed the pasture and climbed up into the tree. We eagerly bit into the marvelous pears and gathered some to take back to camp. What we didn't notice was that while picking and eating the delicious pears, the group of cows that had been in the distance were now just below us and were now accompanied by a large bull with fierce-looking horns that seemed to be just waiting for us to come down. We were frozen with fear and began crying. Worse yet, we had not told our parents where we were going, fearing we would be scolded and told not to go. We truly believed that we would have to remain in that tree until dark or risk being gored if we tried to leave. My sister Julia, who was the eldest, bravely started waving her hands at the bull, saying, "Shoo cow, shoo cow!" Miraculously, the bull finally walked

far enough away from the tree for us to make a run for it—minus the pears. This was probably the only humorous adventure we had during the many years of traveling as migrant farmworkers.

MENDOTA, FIREBAUGH AND COLUSA

Into the early 1950s, we continued traveling from one area of Central California to another, moving from camp to camp and picking whatever crops were available. In Mendota, we lived in terrible conditions in a place known as Rizzo's Camp, where we picked cotton for about two months. If there was not enough work, only my parents and two of my older siblings would go out from Rizzo's Camp to pick cotton at another camp, where they might pick for one or two days. The rest of us stayed in camp. One would think that those of us who stayed behind would have a nice day off. Not so. Remaining in Rizzo's Camp was horrible. Our parents ordered us not to leave the immediate area around our canvas tent, and even if we wanted to play outdoors, we had no place to go—there was dirt and mud everywhere. When rain kept us all from working, we were confined to our leaky, rain-soaked tent. Rain and passing cars created potholes in the camp's dirt roads, which remained filled with standing water. The potholes became breeding areas for mosquitoes, constantly replenishing the existing mosquito population. Sanitation, as in all the other camps, was a major issue. Our restrooms were outhouses, where you would have to wait your turn in line. This was particularly difficult and embarrassing for my mother and sisters, who were forced to wait in line together with the men to use the same toilets.

All of our drinking and cooking water had to be carried in metal buckets from an outside communal water spigot into our tiny shed kitchen near our tent. Hot water for washing dishes and laundry was heated in large pans on a wood-burning stove in the tiny kitchen. This stove was our only source of heat on cold, rainy days. Laundry was hung in the kitchen to dry overnight. To get to the kitchen from the tent when it was time to eat required us to balance on long wooden planks between the tent and the kitchen in order to keep our feet from sinking into the mud. Shelves in the kitchen for holding canned goods and groceries were made from empty fruit crates that had been nailed to the walls.

Since we were far from a town with a grocery store, my mother was forced to buy food at the small, grossly overpriced company store, which was owned

Top: A Mendota roadside green belt, 2012. Near this small farm town, the Areyan family picked cotton in 1947–48. Here, Carmen Areyan, the author's eldest sister, fell headfirst some ten feet into a cotton trailer while unloading her cotton sack. Despite the lack of medical care or facilities, she recovered from a concussion and continued working. *Courtesy of Linda Areyan.*

Bottom: In 2011, retracing the steps of his early years, the author returned to the cotton fields of Mendota, where he picked cotton in his youth. When the cotton plant blooms, the cotton boll must be plucked from the center of a dry, spiked flower head. The spikes cause cuts on the cuticles and fingertips. It was in a labor camp nearby that the author contracted diphtheria and was interned in a county hospital in Fresno, some fifty miles away. *Courtesy of Linda Areyan.*

and operated by Rizzo's Camp. We were not paid for picking cotton each week. Instead, we received the bulk of our earnings at the close of the picking season. The company's labor contractor would record our daily earnings in his ledger and would then report them to the company store, where they would "correctly" credit our earnings on their ledger to determine how much we could spend at the store. My mother would carefully tally our daily earnings in a small black book she carried with her at all times. When she purchased groceries, the cost was deducted from our earnings as shown on the store's ledger. I recall that each time she went to the company store, the clerks consistently disputed the amount of credit we had on their ledger. Fortunately, my mother won those disputes by pulling out her little black book, which was never wrong.

Of all the crops we picked over the years, cotton was the worst, and Rizzo's was the worst of the camps. At daybreak, when we arrived at the fields to pick the cotton, the temperature was in the low thirties, and as we walked, the ground often crunched beneath our feet. The cold was so numbing that we could not pick until our hands had been warmed over a fire made inside a rusty old fifty-five gallon drum. The workers fed the fire with old newspapers, cardboard, trash or whatever they could find that would burn. My mother and sisters wore light cotton gloves with the fingertips removed, which did little to fight the morning cold. By about 10:00 a.m., we would begin peeling off extra shirts and coats as the temperature climbed into the eighties. In the cotton fields, we worked alongside some southern black families and white families who had originally arrived in California during the 1930s Dust Bowl period.

Picking cotton involved putting the looped strap of a long, cylindrical canvas sack around your neck and dragging it in a stooping position between your legs the entire day. The bag was dragged down the rows of cotton as the picker filled it with a minimum of fifty pounds of cotton. When fully mature, cotton bolls are picked from the inside of what becomes a dried flower head, resembling a hard, spiked shell. The spikes of the open shell pierce the cuticles and fingers of the pickers, causing bleeding and small cuts. Cotton pickers could be identified by the cuts and scabs on their fingers. The workers would drag the full bags down the rows to be weighed on a mechanical spring scale suspended from a wooden tripod shaped like a teepee. The scale was well known by workers to be off by several pounds, benefitting the grower, but no one dared complain. Workers sometimes fought back by mixing small dirt clods in with the cotton before weighing, hoping not to be caught. The scale was located near a ten-foot-tall flatbed trailer equipped with metal upright supports covered in chicken wire to contain the picked cotton. Getting to the

top of the trailer to dump the cotton was strenuous and extremely dangerous. The worker had to climb a ladder attached to the side of the trailer, pulling the full cotton bag up to a wide wooden plank spanning the length of the trailer. The worker would then have to carefully walk on the plank to the center of the trailer to empty the sack of cotton. One day, my eldest sister Carmen, after walking across the plank to the center of the trailer, fell head first into the nearly empty trailer bed and was knocked unconscious. Luckily, workers nearby saw her fall and climbed into the trailer to rescue her. My terrified parents insisted that she not work for the rest of the day. With no medical help provided by the grower, my parents could not assess the damage to her head, but it is likely that Carmen suffered a concussion. After a brief rest and without complaining, she returned to work. She was as tough as they came.

The poor conditions at Rizzo's Camp continued to threaten the welfare of my family. One morning, I woke up feeling weak, with an extremely sore throat and no appetite. It had rained the night before, and we could not pick cotton, so the entire family was in the camp. By pure chance, the Fresno County public health nurse was inspecting Rizzo's Camp that day. When she came to our tent to examine me, she took a throat swab culture, which tested positive for diphtheria, a contagious disease normally contracted in crowded conditions by inhalation of an infected person's sneeze droplets. If untreated, the disease forms a thick membrane in the throat and larynx, eventually causing suffocation and death. Having confirmed her diagnosis, the nurse immediately posted large red quarantine signs on our tent and the door of our small kitchen, warning everyone in camp to stay away from our family. My entire family was quarantined, and we were confined to our tent and kitchen areas. We could not work, and no one was to enter or leave the area until we were all examined by a doctor, who was the only person who could lift the quarantine. Later, a doctor arrived and examined everyone. Luckily, my brother Michael, with whom I shared an army cot, was not infected. My parents were ordered by the doctor to immediately take me to the Fresno County Hospital, located about fifty miles away.

When we arrived at the hospital, I was admitted and immediately placed in an isolated room in which anyone entering was required to wear a mask, gloves and a gown. I was about eleven years old and had never been in a hospital or even away from my family—I was scared to death. I did not understand what diphtheria was or what was happening to me. The food I was given to eat was not at all familiar to me. Worse yet, I was not allowed to have any visitors, and it was near Christmas. I remember Santa Claus coming to the door of my room, peering through the window, unable to come in, and

waving a teddy bear, signaling that it was a gift for me. A fully gowned nurse brought the bear to me and quickly left. I remained in isolation for about two weeks, lonely and afraid. When I was taken from my room to be released, the teddy bear that had been my only companion was taken away from me without any explanation. Later, a nurse told me it had to be burned. I cried. I was bathed in cold water and then released to my parents, who were driven to the hospital by my Uncle Transito and my Aunt Anita. The only good memory I have of being in that hospital is that it was the first time I had ever tasted Jello and canned fruit cocktail.

After my release from the hospital, we moved on to Firebaugh, the town adjacent to Mendota, searching for work with the Savedra family and looking for a place to live. Because we couldn't find work and had no place to stay, my Uncle Transito somehow discovered a large, abandoned Quonset hut at the end of a dirt road, off the main highway. We had no idea who owned the hut, and my uncle probably didn't ask anyone. We moved into the hut, planning to stay there only long enough to find more work and hoping we would not be detected. The hut had probably been occupied by occasional duck hunters, as it had a wood stove, a table, some old chairs and a large, dented milk can we used to draw drinking and cooking water from a nearby irrigation canal. At times, we had to remove tiny fish from the milk container before we could drink the water. Today, I wonder what else might have been in that water. The hut was surrounded on the south by desert-like clumps of sagebrush, growing on patches of white alkaline soil. On the north side, some five hundred feet away, there were flooded rice fields that provided food for gorgeously colored ring-necked pheasants. On the west, alongside a large irrigation canal, small mud ducks swam and hid among the reeds.

Once again, we found ourselves with little money or food. However, we were fortunate that Uncle Transito had a twelve-gauge shotgun, which he used to shoot the mud ducks for dinner. This was not good. Once the ducks were cooked, we learned why they were called mud ducks. They tasted just like their name and had to be thrown away. My uncle and dad found that a better choice was to hunt the pheasants in the nearby rice fields. This was good. Over the next two weeks, my uncle shot several large, beautiful birds. These, along with large quantities of pan-fried potatoes, became our principal meals.

During our stay in the Quonset hut, incredibly, we were discovered by local school officials and told we would have to attend school for half days at a local one-room schoolhouse. The fact that we were moving on as soon as we found more work was irrelevant. The next day, my mother sent all seven of us, together with my Savedra cousins, to the one-room schoolhouse, which

was located about a mile away near some railroad tracks. My brothers, sisters and I, despite our different ages, were all placed in the same classroom with one teacher. It was clear to me that we were not there to learn anything. It turned out to be a form of forced babysitting to satisfy the local school officials. This was the first time during several years of migrant farm work that school officials had forced us to attend school. Throughout most of our farmworker years, from September to December, we did not attend school. Even if there were schools in the area, our daily lives were dictated by whatever work was available. Children went to school to learn, but moving as often as every two weeks, learning became nearly impossible for us.

One afternoon, walking along the railroad tracks on our way home from the schoolhouse, my brother Michael, my cousin Gilbert and I found what looked like a red flare alongside the railroad tracks. We were very excited because we had found what we thought was a firecracker. We couldn't wait to set it off. However, it was not what we thought it was, and it nearly turned out to be a fatality for all three of us. Without telling our parents, we snuck matches from the stove and proceeded to the sagebrush area behind the hut. Michael, Gilbert and I attempted to light the fuse, but we ran out of matches, and they asked me to return to the hut to get more. When I was about fifty feet away, I heard a loud explosion, and as I looked back, I saw both boys fly off the ground about two feet and land between clumps of sagebrush and white alkaline soil. I began crying and ran for the Quonset hut to get my mother and aunt, who had also heard the explosion. When we reached the boys, they were crying at the top of their lungs and running around in circles because they could not see. Their eyelashes and eyebrows had been burned off, and they were bleeding from dozens of facial cuts, their burned faces embedded with dirt, gravel and white alkaline soil. Pandemonium followed as all the family members came rushing out of the Quonset hut, crying hysterically and trying to retrieve the boys, who were still running around dazed and blinded. Neither my father nor my uncle was with us at the time because they were out looking for work. Looking back at what happened, it appears we had picked up an explosive dynamite fuse cap. The cap was probably used for setting off larger quantities of dynamite in order to break up long stretches of hard ground during railroad construction.

Once inside the hut, my mother and aunt began carefully removing the embedded gravel from the boys' faces while dabbing their burns with handkerchiefs and cold water and trying to calm their cries—as well as those of everyone else. My mother applied some type of salve and began wrapping their faces with strips of torn cotton dish towels. They looked

Firebaugh is a small farming town adjacent to Mendota. Here, the Areyan and Savedra families lived in an abandoned Quonset hut, and cousins Michael Areyan and Gilbert Savedra recovered from a blasting cap explosion that temporarily blinded them. The cap was found alongside the railroad tracks on the way home from a one-room schoolhouse the children attended in 1949. *Courtesy of Linda Areyan.*

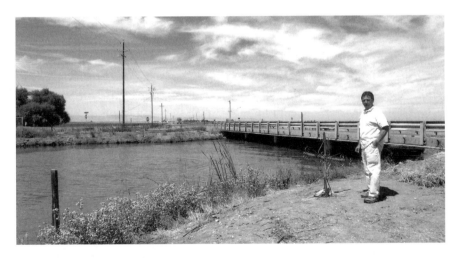

Standing alongside an irrigation canal in Mendota, the author examines a wooden cross memorial to agricultural workers who have drowned in the canals. The banks of the canals are extremely slippery, with no safety ladders to aid in rescues in the fast-moving current. The bridges over these canals are not lighted at night and often become a traffic hazard. Canals like this one provided drinking water for the Areyan and Savedra families when they were stranded in Mendota in 1949. *Courtesy of Linda Areyan.*

eerily like Egyptian mummies. While everyone continued crying, my mother prayed, asking God that the boys not be permanently blinded. About two hours later, my father and uncle returned and took the boys to a local doctor, where they were examined and burn ointment was applied. Their faces were rewrapped with clean dressings, with instructions to keep their eyes and faces bandaged for at least three weeks. The doctor told our worried parents that he would know the outcome only when the bandages were removed. For three more weeks, we were stuck in the Quonset hut, unable to work or move. I'm not sure how we got by, but I remember eating more pheasant, fried potatoes and beans than ever before. At my mother's insistence, we all prayed the rosary daily, asking that the boys' sight be saved. Although their faces were heavily scarred, when the bandages were removed, the boys were miraculously able to see. As soon as they recovered, we left Firebaugh and returned home.

Another time in the early 1950s, one of the most frightening experiences we faced together as a family happened as we tried to cross the Sacramento River on a small ferry in the old Plymouth, heading to Colusa to pick cotton at a different camp. At that time, small farms across the river were reached by crossing over on small, privately owned ferries that carried only three cars. Because the ferry operators were independent, they were unregulated and were not required to have safety features like barriers at the bottom of the loading ramp to hold cars in place in case of an emergency. Cars simply drove down a steep dirt ramp to the edge of the river and waited for the ferry to pull up to the ramp for loading. Once aboard, cars relied only on their parking brake and a thin cable stretched below the license plate to hold the vehicles in place. Passengers had to remain in their cars while crossing.

Early one morning, my entire family was in the old Plymouth, close to the bottom of the loading ramp. As we waited near the water's edge, the parking brake failed. Our car started rolling into the river. My mother, knowing that none of us could swim, screamed to warn us that we were all going into the river. It seems that by some miracle, she was able to grab the steering wheel and turn it hard to the right, crashing the front bumper and fender into the dirt bank and preventing the car from rolling into the river. When it stopped, the car was about three feet short of plunging into the river. That day, my mother saved all of our lives. Luckily, the ferry was returning to the ramp, and the ferry's pilot, who had seen what had just happened, helped us move our car onto the ferry. We made it to the other side and moved on to Colusa to pick more cotton.

SIMI VALLEY

Although the many trips up north had helped improve my family's financial condition, my parents felt that traveling that far was not worth the risks and dangers. In 1951, on our way home from the San Joaquin Valley, we drove through the then-small town of Simi Valley, stopping to visit our cousins, the Colin family, who were picking walnuts. Simi Valley was located only eighty-five miles northwest of Redondo Beach, and travel time was under four hours. After talking with our cousins, my parents were convinced that walnut picking paid more than what we had been earning after traveling over five hundred miles away from home. They reasoned that if the whole family worked seven days per week, we could double our earnings. Simi Valley was closer, and more importantly, we didn't have to cross the dreaded Grapevine to get there. Being in Simi Valley made it possible for extended family members to visit us and join us in the work on weekends. That year, we stayed for the balance of the walnut season, and my parents vowed never to return north to the San Joaquin Valley.

Working and housing conditions in Simi Valley were an improvement over what we had experienced in the San Joaquin Valley, but they were still substandard. Strong and frequent winds accompanied by rain were common. The word "Simi" comes from the ancient Chumash Indian word meaning "the place of the winds." The Proud Ranch became our new home every fall from 1951 to 1955. This ranch was made up of two walnut orchards. One was about eighty acres of Placentia walnuts, and the other was about twenty acres of Eureka walnuts. The twenty-acre orchard was literally right across the street from Simi Valley High School. Each walnut orchard had a small, adjacent orange grove.

On the Proud Ranch, camp housing consisted of five wood-sided cabins with electricity and wood-burning stoves—but, again, there was no indoor plumbing. Because we were the largest family in the camp, our cabin was the largest. The largest room in our cabin accommodated three large beds, on which my parents and four sisters slept, two to a bed. Another very small room, next to the kitchen, held two more beds, on which my two brothers and I slept. Although the kitchen was small, it did have a table and chairs. The cabin floors were made of unfinished wood planks, through which cold wind would whistle during windstorms. Morning fires in the stove were started by a dangerous process of pouring kerosene on the wood, standing back and tossing a match into the top of the stove. My father's job was to start the fire

Above: Rear view of the bungalows at Simi Valley Elementary School, where migrant worker children attended school. These bungalows now serve as a free dental clinic for low-income residents. *Courtesy of Alex Moreno Areyan.*

Left: Gonzalo Bravo Moreno was one of the trusted foremen of Bob Barnes, the manager of the one-hundred-acre Proud Walnut Ranch, from 1950 to 1955. After 1955, Moreno remained in Simi Valley and successfully operated the *El Tecolote* (The Owl) restaurant in Moorpark and the *La Cuesta* (The Grade) restaurant and tavern in the Santa Susana Pass area. *Courtesy of John and Willa Moreno.*

In recognition of the family's many years of hard work and loyalty, Moreno Drive in the Community Center area of Simi Valley was named for Gonzalo Moreno and the Moreno family when the old ranch was sold to developers around 1960. The street sign is located at the west corner of the old ranch, across from the old Simi Valley High School. *Courtesy of Alex Moreno Areyan.*

every morning to warm the cabin. On very cold mornings, I fondly remember him putting our pants on chairs near the stove to warm them. Afterward, he would bring them into our room and tell us it was time to get up.

Outside our cabin, there was an old icebox resting on wooden blocks that held a twenty-five-pound block of ice. It kept our milk and other perishables from spoiling. Under a majestic walnut tree, there was an outdoor faucet that provided drinking and cooking water. The cabin's roof was made of corrugated tin sheets that would fly off at night during heavy winds and rain. My father and eldest brother Rudy would dutifully retrieve the tin sheets in the rain and nail them back down on the roof to stop the leaks.

A two-stall outhouse served as the restroom for the camp's five families. Here, unlike the outhouses in the San Joaquin Valley, there was one stall for the men and one for the women, both of which were clean and orderly. They were also equipped with Sears catalogs in case of an emergency. The best thing in the camp was the shower building, which luckily was located next to our cabin. Bob Barnes, the kind ranch manager, generously had the

aluminum building constructed for the workers and their families. For me, this was almost like having a sauna next door. This was the very first time as migrant farmworkers that we had the luxury of enjoying hot showers. The one small problem was that on Saturdays and Sundays, the butane–fed water heater was burdened by such heavy use that waits of an hour for replenished hot water were standard. Everyone used this rare downtime to talk and visit while sitting on small benches waiting under the big walnut tree.

Harvesting walnuts required the use of twelve-foot-long poles with metal hooks on the end and two men to lift them into the tree branches in order to shake the fruit from the trees. My father and eldest brother did the pole shaking and developed leather-like calluses on their fingers and palms from using the shakers from sun up to sun down, sometimes seven days a week, unless it rained. Gloves could not be used because they prevented the hands from gripping the poles. Walnuts were picked by forming a human fan outward from the tree trunk to the outer limbs and then stooping, bending or kneeling to pick up the walnuts from the ground. The fruit was collected in empty five-gallon paint cans. The filled cans, weighing about twenty pounds each, were then carried and emptied into burlap sacks on the side of the dusty road for pickup. The picking pattern was almost a case of déjà vu—it was as if we were picking plums all over again. Picking walnuts always required peeling off some of the leftover husks, causing the fingers to turn black. At school, we were always embarrassed by the black fingers, which immediately told the other kids we were walnut pickers. The good news was that we were paid an average of one dollar per sack, and on a very good day, our family would pick up to one hundred sacks or more. If we picked six or seven days a week, we earned more money than ever before. What I was not aware of during the years in Simi Valley was that my mother quietly continued to save money to remodel the house that we had had moved to Redondo Beach.

Opposite, top: A Simi Valley walnut orchard is the setting for this circa 1951 photograph. Here, Carmen Areyan Soriano (left) and friend Franco pose in front of the family's 1940 Chevrolet sedan. Carmen, the eldest of the Areyan family's four daughters, left school after eighth grade to help support the family. Note the gloves she used to protect her fingers from black stains left from husking walnuts. *Courtesy of Inez Areyan.*

Opposite, bottom: An aerial view of Simi Valley Elementary School, circa 1950. This is one of the elementary schools attended by the author and his siblings from 1951 to 1955 while picking walnuts on the Proud Ranch. The ranch was managed by Robert Barnes, who treated farmworkers with dignity and respect. At top left are two gabled-roof bungalows, where migrant worker children were segregated from the main school in the foreground. *Courtesy of Strathearn Historical Park and Museum.*

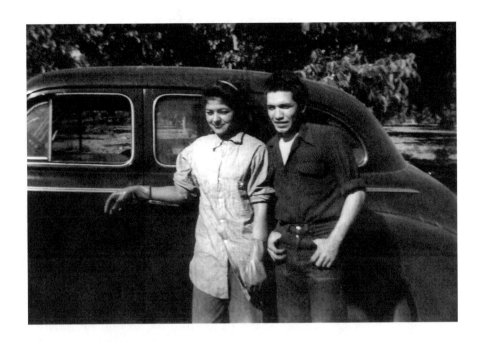

Between 1951and 1954, from September to December, my siblings and I attended either Simi Valley Elementary School, about a half mile's walk from the Proud Ranch, or Simi Valley High School, which was across the street from the twenty-acre Proud Ranch walnut orchard. Unlike at the prior camps, here we were required to attend school during the picking season. I didn't realize it at the time, but the two bungalows where we had our classes, located at the south end of the elementary school, were actually segregated classrooms. Here, only migrant farmworkers' children attended classes. Even though everyone looked brown like me, I naively thought we were separated from the rest of the students only because we attended school until noon. My older sister Julia, who was always very bright, had a teacher there named Mrs. Link, and in a rare moment of mischief, Julia wrote on a sheet of paper, "Mrs. Link Stinks." She didn't get in trouble for this, but I think Julia may have understood our segregated status better because she was older.

While attending Simi Valley Elementary School, we didn't have any extra money to buy Halloween costumes in order to go trick or treating in the small housing tract across the street from the school. My siblings and I would fight over who could get the most soot off the bottom of the water-heating tubs at the rear of the cabin to put on blackface to go trick or treating. We thought by doing this, we could get more candy by going to the same houses more than once without being detected. I attended Simi Valley Elementary School for three months of the year until eighth grade, never feeling like I had made any friends or assimilated with Anglo students, as we rarely interacted. After this school, I began attending Simi Valley High School in the fall of 1955.

From an assimilation standpoint, my student life at Simi Valley High School was awkward and embarrassing. The majority of the student body was Anglo, and they came from long-established ranching and farm families, many of whom were pioneers in the valley. Not surprisingly, the school mascot was the Pioneers. Local Mexican American kids who were not farmworkers were the only ethnic minority group at school and the only ones who truly befriended the walnut pickers. These students were the children of Mexican American families who had lived in the valley for many years, and they knew everybody. When students like me showed up at school in the fall, it was immediately apparent that we were walnut pickers. One look at our black fingertips said everything. However, in the early fall of 1955, in a gesture of friendship and a rare moment of assimilation, my brother Michael and I were invited to a nighttime high school dance

in the gymnasium by some of the local Mexican American students. It was fun but very awkward. The Anglo kids stood on one side of the gym, while we stayed on the other. The local Mexican American boys would cross to the other side to dance with the Anglo girls, while my brother and I remained on our side of the gym. Ironically, it was at this dance that my brother Michael first met Karen Stone, who was also a student. In later years, Michael and Karen would marry and have four children. Karen had grown up in a small neighborhood of Simi Valley where Anglo and Mexican Americans were neighbors.

As a freshman at Simi Valley High School, my self-image suffered. My social standing as a student was overshadowed by my migrant worker status. Coupled with approximately three months of attendance, this made it nearly impossible to form any friendships or assimilate in any way. I saw myself as just another migrant farmworker with a limited education and black fingers that identified my station in life. I often wondered at what point my life would change so that I could feel like everyone else in high school. Somehow, without knowing how or when, my instincts told me that my life would eventually improve. After all, I thought, how much poor luck could one person have?

The last event at Simi Valley High School that caused me embarrassment and humiliation happened one morning in the late fall of 1955. We were about three weeks away from the end of the walnut harvest, which meant we would be heading home. While sitting in a first-floor classroom located at the far eastern end of the school, I looked out an open window across Royal Avenue and watched as my parents and siblings stooped and kneeled while picking walnuts about 150 feet away. At that moment, I experienced an overwhelming sense of both guilt and embarrassment—I was sitting in a class learning history while they were hard at work without my help. I did not realize then that education was the key to breaking the stranglehold of the migrant farmworker cycle. Leaving school at noon that day, I thought of myself as just another migrant farmworker with black fingers—with no education and no future. I left school by walking to the back of the school behind the gymnasium, across the football field and into an orange grove. Next, I crossed Royal Avenue to another orange grove and then backtracked to the orchard where my family was picking. By taking extra time to walk home, I gave my family enough time to move farther away from the school so that no one would see me and my family picking once I joined them. This memory remains with me to this day.

Old Simi Valley High School, circa 1950s. The author attended this high school as a freshman in the fall of 1955, the last year his family picked walnuts or any other crops. *Courtesy of Strathearn Historical Park and Museum.*

In December 1955, just before Christmas, we went home, and I returned to Redondo Union High School to finish my freshman year. Finally, my crop-picking years had come to an end. It was now time to try to develop new friendships that could improve the assimilation gains I had made at Hillcrest Junior High School in seventh and eighth grades—but I feared that I might have to start all over again.

BEGINNING TO FEEL ASSIMILATED: HILLCREST JUNIOR HIGH SCHOOL

My family worked as migrant farmworkers for eight years. When we started, I was only seven years old and attending Beryl Heights Elementary School for the months that we lived in Redondo Beach. In 1955, when we stopped going north to work, I was in my first year of high school. In 1953 and '54, I attended Hillcrest Junior High School during the school months that we were in Redondo Beach. During those years, upon returning to Redondo Beach from Simi Valley, my mother would resume doing housekeeping work in the homes of wealthy families on the nearby Palos Verdes Peninsula. She had been doing this work since about 1951, working from January to September, until we went north. For my two years of junior high school, I became her helper when she had extra work, but I didn't dare tell anyone about this work, because I was afraid my friends at school would think of me as a servant.

My mother worked primarily for one family that owned a nationally known charcoal briquette company. In their home, I learned to vacuum, change beds and clean windows. For special dinner parties, I polished silverware, removed water spots from crystal ware and helped my mother set the dinner table. The family's home had large bedrooms, a huge den, a guest bedroom and a massive sunken den/library with a huge polar bear rug. During slow periods, I would sneak down to the library while my mother worked and lie on the rug, resting my head on the bear's head while glancing through a few of the hundreds of books lining the shelves. I didn't understand most of the books, but I enjoyed looking at the pictures. The home also had an underground wine

cellar under the central courtyard, which I was told not to enter but secretly explored. The family had their own gasoline pump, where Fred, the chauffeur, filled the Chrysler limousine and the Chrysler four-door sedan before we went grocery shopping.

It was here, during eighth grade, that I first met someone who was "in college," although I wasn't sure what that really meant. I was introduced to Joan, the family's only daughter, and told that she was graduating from college, a place called Vassar. Joan then introduced me to a handsome military officer to whom she was engaged to be married. They married soon after I met them both. Their son, Robbie, was born the following year, and unfortunately, Joan passed away before their son was a year old. My sisters Julia and Mary periodically joined my mother and me, helping the grandparents care for their grandson.

Being in this wealthy environment caused me to ask myself, "Why does this family have so much and my family have so little?" Though I had not heard the word "college" mentioned at home, I somehow thought that if Joan was "in college," it was something she had to do to be wealthy like her parents.

For me, junior high school was all about transitioning from elementary school to junior high with all the attendant insecurities I brought with me from Beryl Heights. It was the beginning of my awkward teenage years, and I struggled to make friends among the boys and girls as I tried to fit in and assimilate. It was an especially difficult time because I was unsure of myself, still not comfortable with who I was, and I continued hiding the fact that I was still picking crops. I worried about my classmates and teachers questioning why I would have to leave so soon after the beginning of school. I must admit that I did a pretty good job of concealing why I left, because no one ever questioned me. I often felt like I was living a Dr. Jekyll and Mr. Hyde kind of existence. At Hillcrest, however, there was something I couldn't conceal: I was four foot eleven. I was very impressionable, had developed a chip on my shoulder and had just begun to notice girls.

I was keenly aware of the chip on my shoulder and my insecurities as I looked for ways to fit in with my peers and feel included at school. I didn't want to repeat the feelings of exclusion that I had experienced at Beryl. I started by carefully observing both my male and female friends for clues. The first criterion was to be popular among both groups. With the boys, active participation in sports was vital. You had to project an image of confidence and some degree of bravado to show that you could take care of yourself in case of a challenge by other boys. This was very important. The bigger boys on the football and basketball teams had to like you, and they expected you

to be aggressive enough to help them win games if you were invited onto their teams during physical education classes. I quickly realized that if you didn't exhibit these qualities, you would always be the last one to be picked for the teams. Even worse, if you were passive, you stood a good chance of being bullied, ignored or left to play with all the slow guys.

Wearing the right clothes and always looking neat was a way to impress the girls. Acceptance was largely based on popularity and showing girls respect by being polite. Being "cute" topped the list. Somehow, ethnicity was not important to either the boys or the girls, but it was an ongoing concern for parents who wanted to be sure their kids were not mixing with the "wrong crowd" (i.e. Mexican Americans).

At Hillcrest, I was nowhere near a natural athlete, but I came to realize that this was a liability that could possibly be overcome by focusing the negative energy of the chip on my shoulder into sports. During physical education classes, I competed aggressively by demonstrating high levels of energy, stamina and assertiveness in both basketball and touch football. Because I was small, I was fast and could outrun many of the other boys on the touch football team, which was important for catching long passes. When running laps around the football field before and after playing football and basketball, I struggled but was consistently in the top five or six runners at the head of the pack. I wanted to prove to my classmates that by showing determination and assertiveness, I was competitive enough to be selected to join the better-known athletes on both the football and basketball teams. It seemed to work. I was subsequently invited to play during morning breaks and lunch periods. After my first year of increased sports participation playing on teams, I needed to have more than one pair of shoes, and thanks to my older siblings' increasing paycheck contributions to the family fund and my mother doing housekeeping work, I was able to wear new clothes and had several pairs of shoes, including new tennis shoes. These changes were a great help in making me feel more like I was one of the guys and further increased my sense of belonging and self-confidence.

At home, despite the fact that we would still pick crops for another two years, my family's standard of living was improving. My older siblings began to have part-time jobs, which greatly improved my family's financial condition and created a sense of well-being. As a bonus, I still remained good friends with all the boys from the old neighborhood. For the first time, I started feeling socially assimilated. Hillcrest was good for me. It was an important new beginning.

Many of my friends were now Anglo kids with names such as Don, Sam, Larry and Doug. Doug was a little different. He was a smoker at thirteen. He had moved to Redondo Beach from Fontana, California, and belonged to one of the Anglo families in my neighborhood. His father provided him with cigarettes. Doug's father commented that he would rather buy his son smokes than have him sneak behind his back if he wanted to smoke. I walked to school with Doug for nearly two years. He was a bit of a rebel. He taught me to smoke in a tiny teardrop camping trailer his family kept in their backyard on the rare occasions when my parents allowed me to stay overnight at his house, believing that his parents were closely supervising us. One of those nights, at about 1:00 a.m., we snuck out of the trailer, walked down the street and pilfered day-old doughnuts and cookies from his neighbor's Golden Krust bakery truck. We then snuck back to the trailer to feast on our ill-gotten gains. If my parents had known about this, our friendship would have ended immediately—no questions asked.

One morning on the way to Hillcrest, Doug and I stopped under a bridge a block away from Hillcrest, when he pulled out a marijuana "joint" and started smoking. He offered me the small, different-looking twisted cigarette, telling me it would make me feel good. I was scared s---less, thinking someone might see us from the top of the bridge, since possessing marijuana in the mid-'50s was a serious crime that could bring jail time. I turned him down. This was the second time I had been offered marijuana. The other offer had come from an old neighborhood friend earlier that same year. He told me it was called *yesca* (Spanish slang for marijuana), but he never showed me the actual cigarette. Both times, I remembered that my parents had warned me that marijuana would rot my brain. I believed it, and I said no to my friends. My old neighborhood friend who offered me the first joint later died from a heroin overdose at the age of nineteen. This was a horrible waste of human life, especially since this friend could cite Shakespeare from memory and also showed promise as an artist. At the end of eighth grade, my rebel friend Doug moved back to Fontana, and I never saw him again.

The feeling of increased assimilation at Hillcrest continued into 1954, when I rejoined my friends at school after returning from picking crops up north in December. Thankfully, no one asked me where I had been. Again, I started participating in sports, but ironically, my growing self-confidence created a bit of a negative side effect. I began developing a reputation for being feisty and a wisecracker. Disagreements with some students sometimes turned into shoving matches and occasional scraps. The chip on my shoulder had gotten smaller, but I was still carrying around a smaller version. On

the positive side, despite my size, no one ever bullied or intimidated me. Unfortunately, for a short a time, some of this conduct would follow me to my freshman year at Redondo Union High School.

My eighth-grade graduation was a happy but also very sad occasion. Unexpectedly, Hillcrest's principal announced that, despite the fact that Redondo's high school was only two blocks away, some graduates would not be attending there in the fall. He explained that because Mira Costa, a new high school, had recently opened in Manhattan Beach, many students would be attending that school, as it was nearer to their homes. I was crushed. This meant that not only was I going to be separated from my new Anglo friends, from whom I had learned so much about friendship and belonging, but also that I would not have them to help me with the social uncertainty of transitioning to high school. I would have to find a whole new set of friends. I felt that all the effort I had put into being a different person, gaining new friends and feeling accepted was a total loss and waste of time.

NAVIGATING THE ASSIMILATION MAZE: REDONDO UNION HIGH SCHOOL

In the fall of 1955, when we returned from Simi Valley for the last time, our migrant farm work earnings finally allowed my parents to finish remodeling the home they had bought several years before. My family's standard of living was now greatly improved—my father was now working in construction, my mother continued doing housekeeping work in Palos Verdes and most of my siblings also held jobs. Though they did not earn a high wage, collectively they earned enough money that we did not have to return to migrant farm work. Their paychecks went into a family fund administered by my mother, who provided them with whatever money they required for their personal needs.

Our remodeled home had a huge kitchen with ceramic tile countertops, large custom-made cabinets, a chrome dinette set and new appliances. Our bedroom floors were now polished hardwood, and our windows had new Venetian blinds. For me, the greatest improvement of all was that we finally had new indoor plumbing, which included an enclosed combination bath/ shower with etched flamingos on the doors. All of these big changes made me remember how it felt not to have an indoor bathroom during elementary school and the early part of junior high school. I am sure that it is hard for someone who never lived as I did for so many years to understand how I felt, but these improvements in my life created a huge psychological difference for me. Finally having a home equal to those outside our neighborhood lessened my feelings of being so vastly different from Anglo families and improved my confidence and self-image. It even helped me feel better about my family's

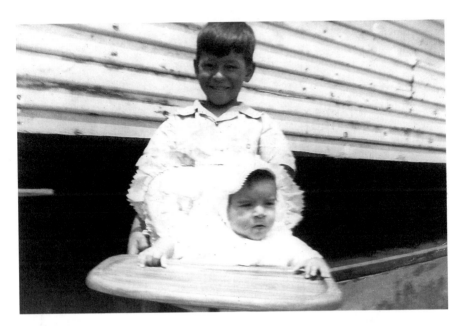

Ignacio "J.R." Estrada and the author, 1950. The house seen in the background was originally located in the San Fernando Valley but was moved to 1718 Morgan Lane in North Redondo Beach after Estrada's father built the foundation and completely remodeled the interior. This was the author's first house with indoor plumbing. *Courtesy of Inez Areyan.*

standing in our own neighborhood. For me, 1955 was a defining year in my personal life. It meant that after years of struggling as migrant farmworkers with all of the sacrifices made by my parents and siblings, our family had finally broken out of the cycle of poverty. I was now in a much better position to assimilate into the broader Anglo American mainstream.

There was still the issue of fitting in as a freshman at Redondo Union High. It was a time of great apprehension, confusion and uncertainty. I no longer had the social support network from Hillcrest Junior High School, since all of my close Anglo friends had gone on to their new high school. Right or wrong, I felt abandoned by my friends, though what happened was certainly not their fault. I missed their friendship and the sense of assimilation they had helped me to achieve. I felt socially lost. Though I still had my old loyal neighborhood friends, I felt the need to reach out and make new friends beyond those in my neighborhood. Adding to my high school apprehensions were the stories I had heard from my neighborhood friends about upperclassmen in physical education classes who hazed, bullied and otherwise intimidated freshmen. And I was still four foot eleven.

Looking around Redondo Union High School that year, I carefully examined the student social landscape and demographics to figure out where I could develop new friendships and fit in, much as I had done in junior high school. In a short time, I confirmed what I already knew about Redondo Union High School from my older sisters, Julia and Mary, who had graduated in 1953 and 1954. The largest ethnic group at school was Mexican American, followed by a small number of Japanese American students from families that farmed the agricultural fields in the surrounding area. Only one black female student attended the school. The percentage of Mexican American students probably never exceeded 5 percent of the student population. A look at my sisters' old school yearbooks was telling: 95 percent or more of the student population did not look like me or the other Mexican American students. The campus was not exactly a model of racial or cultural diversity.

It was my impression that Mexican Americans were not unconditionally accepted by the majority of Anglo students on campus or by the administration. It is important to note that I never faced any open or obvious form of ethnic bias or attempts to hinder or prevent my social assimilation by any students on campus. However, in a subtle way, we knew our place. For example, there were social and economic barriers that impacted full assimilation by Mexican American students. For starters, we didn't look like everyone else; we looked different. Our physical appearance was dominated by brown—not pale, white or black skin—and we did not have blonde or sandy brown hair or blue eyes. Our first and last names were spelled differently and sounded different. We sometimes spoke English with a slight Spanish accent, and our command of English was not at the same level as that of our Anglo classmates. Admittedly, we may have added to the problem, because it was natural for us to seek and find acceptance by associating mainly with students who looked and spoke like us and shared the same ethnic identity.

Beyond social assimilation, there was also the matter of economic assimilation. By their sophomore year, many Anglo students owned the all-important social and economic differentiator: a car. Whether Anglo students earned money by working after school or at summer jobs or borrowed from their parents, they had cars. Many students with cars would say they earned all the money to buy their car, but the reality was that many parents provided at least some degree of financial support. This was especially true because car ownership included the daunting cost of auto insurance for teenage drivers.

Owning a car in high school immediately put you into a special social and economic class and opened up important new doors of assimilation. Cars increased your popularity, and the newer the car, the higher your social status. With a car, your circle of friends on campus multiplied overnight. For boys, cars were an extremely important asset for attracting girls, going on dates and attending parties or away football games. Even if you were not part of the "in" social crowd, having your own car could make a big difference in terms of potential social acceptance. I distinctly remember the first Mexican American boy who came to school driving his mid-1950s Volkswagen around 1957. He was the talk of the school. To top it off, all the girls thought he was "cute." This guy did not seem to have an assimilation problem, although he was a bit shy. He was the one big Mexican American exception to car ownership. Few Mexican American students that I knew during my freshman and sophomore years had families with large incomes. Like me, most of them came from hardworking, blue-collar families with modest incomes. I cannot recall knowing anyone from my neighborhood who had a part-time or summer job to pay for a car. It seemed that the available jobs for students were mostly obtained by Anglo students through family connections with local businesses or with Anglo parents lobbying businesses or friends for jobs for their kids. Mexican American kids did not have these connections, and as a result, we seemed to be at an economic disadvantage when it came to owning cars. Moreover, our families could not afford to provide financial assistance to help us buy cars. Navigating socially without a car was not easy, especially for boys from my neighborhood. I was very lucky my junior year, because I inherited an old 1941 two-door Chevrolet sedan from my brother, who went on a temporary state vacation for unpaid tickets. The first thing I did to my shiny black sedan was lower the front end by cutting one and a half coils out of the front coil springs. I also bought chrome Appleton spotlights for the driver and passenger sides, which were very popular then, and I always kept the car highly polished. Car ownership as a means of social assimilation and popularity in high school was the ticket.

Assimilation for Mexican American girls may have been more difficult than it was for boys because organized sports and car ownership were not realistic options for them in the late 1950s. Most Mexican American girls did not participate in school clubs or activities, possibly because of shyness or because they preferred social involvement with a small group of close personal friends with whom they felt comfortable.

Since Anglo students rarely invited Mexican American students to join school clubs and organizations, there was no easy way for Mexican American students like myself to penetrate the school's social structure. Based on my observations, it would be fair to say that during my freshman year, I saw that Mexican American students were socially accepted but not necessarily made to feel welcomed. For me, this changed my sophomore year, when I made a painful self-assessment that led me to consciously begin to reach out and initiate social interaction instead of waiting for people to approach me. This made it possible for me to accelerate the rate of my assimilation.

SPORTS AND ASSIMILATION AT REDONDO UNION HIGH SCHOOL

It is a universal truth that the most important part of high school for everyone is to experience the feeling of belonging and fitting in. With the friendships I made at Hillcrest, I had learned that playground sports were one sure way to gain social acceptance and to move more easily into the assimilation path. At Redondo Union High, I learned that in addition to sports there were other tracks to assimilation, but organized sports remained the most commonly recognized way.

At Redondo Union High, sports were dominated by Anglo athletes. Many of them came from old-legacy sports families. Their fathers, brothers and relatives had established athletic traditions, some extending as far back as the founding of the school in 1905. Descendants of these legacy athletes were expected to continue those traditions. The pathway for Mexican American athletes was not the same. They did not have the long established traditions of sports involvement by past family members to emulate. Redondo Union High's Mexican American athletes could look back only to the mid- to late 1940s to find outstanding athletes such as Marcus, Emo and Florencio "Socko" Torres; Nick Vargas; Danny Espinosa; Ricardo Real; and others who began establishing strong sports traditions. Socko Torres won fifteen sports letters in four sports in four years ending in 1948. When I interviewed him in 2006, he explained that Mexican Americans did not try out for sports in large numbers at Redondo Union High because they usually came from large families who did not encourage sports participation, instead expecting

them to work to help support their families. He explained how difficult it was for him to be able to have the opportunity to participate and excel in sports because his father expected him to work in the family's home business of assembling Mexican huarache sandals. This was verified by his good friend Henry Burke, who would help Torres assemble the shoes to help him get out of the house faster to play sports. Torres also stated that coaches at Redondo High did not actively reach out to Mexican American athletes. He thought the coaches may have mistakenly perceived that since Mexican Americans did not try out for sports in large numbers, they were either not interested in sports, lacked the confidence to try out or didn't exhibit the competitive spirit coaches looked for in school athletes. Looking back at my experience as a freshman, even though I was never going to be a highly successful athlete, I might have been more encouraged to participate if I had known athletes from my own neighborhood that had successfully competed in sports at Redondo Union High.

CLUBS, ORGANIZATIONS AND ASSIMILATION AT REDONDO UNION HIGH SCHOOL

Another path to rapid assimilation was to join school clubs and organizations. The easiest way to join an organization was to be personally invited by a friend or a current member. By joining this way, a student avoided creating the awkward appearance of lacking friends. As a freshman, I knew only a few people on campus, and they were mostly from my neighborhood, so getting invited to join organizations by them was not possible because they did not belong to any. As I looked around for evidence of Mexican American boys or girls belonging to clubs and organizations, I rarely saw any of these students represented. If there was representation, it seemed like they were all juniors or seniors. To me, it appeared that clubs and organizations, like sports, were also dominated by Anglo kids. If you ran for a student government office, it was tough to win because if you didn't have the support of friends in organizations, the chances of winning an election were minimal. If you ran and lost, there was also the problem of dealing with the humiliation of appearing to be a loser.

FAMILY BUSINESSES AS A PATH TO ASSIMILATION AT REDONDO UNION HIGH SCHOOL

Assimilation was often easier for the few Mexican American families who owned their own businesses. These families owned topsoil businesses, nurseries, Mexican restaurants, small delicatessens and even a ready-mixed concrete business. Usually, these business owners had homes that were located in predominantly Anglo neighborhoods or were close to Anglo businesses. As a result, the Mexican American students whose parents had businesses tended to assimilate faster. Their parents' businesses provided them with opportunities to have personal interaction with Anglo business owners and their families. In turn, these interactions produced social ties among business owners' children, which developed into social relationships at school.

Peter's Garden, an upscale nursery in Redondo Beach that was established around 1941 by Peter Serrato Sr. and his family, is one example. Peter Serrato Jr. and his brothers, Bobby and Ronnie, rapidly and successfully assimilated at Redondo Union High School, especially through sports and other activities. Today, Peter Serrato Jr. and his daughter, Tere, operate the business. Many of Peter's Anglo and Mexican American friends from his late 1940s high school days continue to gather there for morning coffee klatches to reminisce.

CULTURAL BLENDING AND ASSIMILATION IN HIGH SCHOOL AND BEYOND

Another method of assimilation in high school was an informal process I describe as "cultural blending." This phenomenon occurred when Anglo and Mexican American students interacted socially and blended their cultures together. It was the most enjoyable and least complicated way to assimilate. This blending brought together students from both cultures and forged enduring bonds of friendship that survive to this day.

Cultural blending grew out of natural social interaction between both groups in settings such as weekend parties, Seahawk football games, hanging out at the beach during the summer and coming together at a local youth gathering place known as the Hideout or the Canteen.

Above: These forward-looking Redondo Union High School graduates started sponsoring the tradition of December get-togethers at the Redondo Elks Lodge more than twenty years ago. They have successfully continued reuniting past high school friendships, many of them formed at the Hideout Youth Canteen. *From left to right*: Bob Mauck, Ronnie Serrato, Mike Salsido, Joe "Chuy" Rodriguez and Kenny Dietz. *Courtesy of Alex Moreno Areyan.*

Opposite: A membership card for the Redondo Beach Hideout Youth Canteen for 1959 and 1960. The Hideout played a vital and perhaps unintended role in the social, cultural and ethnic process of assimilation for many Redondo Union High school students. It attracted students from all walks of student life, including athletes, Soches, Lowriders, independents and the academically talented. *Courtesy of Ronnie Serrato.*

This cultural phenomenon manifested itself at school when Anglo surfers wore their Catholic Saint Christopher medals outside their white Penney's T-shirts and wore Mexican huarache sandals on their feet. At parties and dances, everyone would dance to the *corrido* (ballad) rock and sing along with Ritchie Valens's song *La Bamba*, even though they didn't understand the words. After school, many students would gather together at Taco Tio's, the cheap Mexican take-out restaurant in South Redondo that served as party central for Redondo Union High students and was the go-to place to meet and greet. At football games, Ronnie Serrato, a compact and outstanding halfback, invented a single-word Spanish cheer—*"Bueno!"*—which was used to acknowledge an outstanding play or a touchdown.

Cultural blending, however, did not necessarily translate to mixed dating, as far as some parents were concerned. Parents' anxieties centered on their

Carol McKenna Savedra and Jay Savedra, who met in high school, are loyal Seahawks and Redondo Elks Lodge members who have been attending reunions and get-togethers for more than twenty years. *Courtesy of Tom Volpi.*

Time and distance have not affected this friendship. Ronnie Serrato (left), the longest-living Mexican American DJ in Southern California, still resides in the old family home in Redondo Beach. Tom Volpi (right) lives in San Jose and is the Redondo Elks official photo historian. Ronnie and Tom are known for the hilarious skits they've performed at past reunions. Despite living some four hundred miles apart, they have remained close friends since the days at the Hideout. *Courtesy of Tom Volpi.*

Christmas trees, camaraderie and coffee connect these old friends in December 2012. *From left to right*: Donny Hand; "Hammerin'" Henry Burke, former sportswriter for the local *South Bay Daily Breeze* newspaper; Peter Serrato; Chuey Hernandez; Tommy Heffner; and Danny Espinosa. *Courtesy of Alex Moreno Areyan.*

fear that friendships between the cultures might encourage mixed dating or, heaven forbid, marriage between Mexican American boys and their Anglo daughters. These concerned parents did not encourage their children to invite Mexican Americans into their homes, probably worrying about what the neighbors would say. If their children wanted to date someone from North Redondo, the questions they would ask were probably: Last name? First name? What do their parents do for a living? Where do they live? These questions quickly identified ethnicity, class and economic status. Despite all of this, the students themselves did not have a problem mixing. The easy way around parental hang-ups was to meet at private parties, Taco Tio's, football games or the Hideout, which were all activities that strengthened cultural blending. Despite the parental concerns of the past, cultural blending created friendships that have endured. Many of the students with whom I attended Redondo Union High School reconnect at annual Christmas reunion parties held at the Redondo Beach Elks Lodge, with DJ Ronnie Serrato providing the old tunes. These reunions, which have been celebrated for more than twenty years, continue to attract growing numbers of longtime high school friends and have long outlived the old prejudices of

Above: Dancing the Mexican *corrido* (ballad rock) at the 2012 Redondo Elks reunion. *Left to right*: Isidro "Sid" Delgado, Sharon Dietz, Sally Savedra Marshall, Pat Hart Herrera and Sylvia and Gale Griffith. At center rear is Artie Ybarra. *Courtesy of Tom Volpi.*

Opposite, top: Brothers Tom (left) and Rocci Volpi attended Redondo Union High School together, where they actively participated in sports and had many mutual friends. Regrettably, both relocated from Redondo Beach to San Jose, disappointing their many friends. Rocci and his wife, Loretta Jones Volpi, successfully owned and operated Rocci's Auto Body in Morgan Hill. Rocci and Loretta also played an important part in the author's assimilation journey. *Courtesy of Tom Volpi.*

Opposite, bottom: Jim Bailey (left) joins friends Norm and Sally Savedra Marshall at the 2012 Redondo Elks December gathering. Every year, Jim travels some five hundred miles from his home in Spring Valley to attend the gathering, while Norm and Sally, married forty-eight years, travel about five miles from their home in Redondo Beach. All three friends are avid classic-car fans and owners. *Courtesy of Tom Volpi.*

nervous parents. A number of bicultural high school relationships resulted in intermarriages that have produced beautiful offspring.

There was at least one exception to the home friendship issue that I personally recall. It involved a Mexican American and an Anglo American, but this relationship was different—it involved two males. Around 1954, when the ethnic makeup of my neighborhood was changing, working-class Anglo families began moving into modest new homes in my neighborhood. They were attracted by the affordable homes with a Redondo Beach address. The Doss family was one of the first arrivals in 1955. The family of five included a son named Gary, who was close to my age. We met at the local playground. He was a stocky, tough, redhead of German American heritage who wore his hair in a flattop. We were complete opposites in culture and appearance, but somehow we became instant friends and were almost inseparable. He adopted the neighborhood style of dress, including the khaki pants and shiny shoes, and he learned all the choice Spanish swear words. Gary absolutely loved beans and tortillas. He converted and became a German-Mexican American, and he was perhaps my best neighborhood friend. Almost daily, we would visit each other's homes to find out who was having what for dinner. About 80 percent of the time, he would eat at my house, where he satisfied his incredible appetite for beans, tortillas and generous amounts of homemade salsa. He never mastered the Mexican "tortilla scoop" technique, which involved grasping the tortilla with both hands, tearing off a small piece with the right hand and creating a small scoop. The rest of the tortilla was rolled up in a coil and held with the fingers of the left hand as you pushed the rolled piece of tortilla toward the scoop to capture the beans. Gary's answer to the scoop was to tear the tortilla in half, plunge it into the bowl of beans and with three finger of his right hand capture what beans he could. The end result was three dripping fingers with a few captured beans—and many napkins. He never talked while eating, devouring the beans as if it were the last meal of a condemned man. He liked telling his mother that the Areyan family did not own silverware. My relationship with Gary was outside the rule that mixed friendships were not encouraged in Anglo homes. But if I had tried dating his sister, the results would probably have been different and would have ended our friendship. In a twist of irony, I probably helped Gary assimilate into the Mexican American culture a little bit more than the other way around.

MY SOPHOMORE YEAR AT REDONDO UNION HIGH SCHOOL

As a freshman, I had been quick and agile in gym classes, but now when I played basketball, I became far more assertive and gutsy. It wasn't as easy as before, but I was still stealing the ball, passing it to taller boys and even beginning to score. This caused Coach Mike Burley to invite me to join the school's wrestling team. I began wrestling in the ninety-eight-pound weight category and eventually won two second-place medals at large tournaments. I also earned my junior varsity wrestling sports letter. Unfortunately, before the start of the wrestling season during my junior year, Mr. Burley asked me to leave exercise drills when he caught me doing pushups from a kneeling position and being insubordinate. I decided to try "C" football, managing to play with a team during gym classes but warming the bench during actual football games. The friendships I made on the football team began to feel like the ones I had developed in junior high school. My circle of friends around the campus began expanding rapidly. As in junior high school, this boosted my feelings of acceptance and made me feel like I was fitting in. These changes made me realize that experiencing a greater feeling of inclusion was the most important thing in high school to me.

For this to continue, I knew that I needed to take a serious look inside myself. I had to examine some of my past social behavior if I genuinely wanted to enter the social mainstream and assimilate further. This would be painful, but I challenged myself to start by doing a mental self-assessment—looking at my past conduct, attitude and behavior. How was I relating to others around me? Who was I? I came to realize that in elementary school, junior high school and up to this point in high school, my feelings of insecurity, poor self-esteem, lack of confidence and exclusion were tied to growing up poor in the working-class part of the city. There were many factors that made me feel as if I had been a victim of my environment and had been powerless to change my life. These factors included living in substandard housing without indoor plumbing until I was fifteen years old, being small and brown and the personal embarrassment of being a migrant farmworker and trying to hide that fact. It was humiliating to me that my family had to resort to picking crops in order to survive. These were demons that I would have to face. These factors operating together caused me to experience alienation, frustration and resentment, resulting in my acting out against others in a misguided

attempt to gain recognition and attention. I mistakenly believed that this was the way to be noticed and accepted.

Having done this unscientific analysis, I had some ideas for making changes that could move me closer to my personal goal of feeling more included and socially assimilated. I would try to lose the chip on my shoulder by reaching out in friendship to others, and I would move beyond the feelings of being a victim.

My Junior Year at Redondo Union High School

It was a complete surprise when, toward the end of my sophomore year and during that following summer, I grew an incredible four inches. Suddenly, I was no longer the last one to be picked to play basketball in gym class.

In 1957, I was experiencing a musical love affair with percussion instruments. My sister Mary had grown tired of my banging on kitchen pots and pans while listening to Latin music on Chico Sesma's "Con Sabor Latino" music program on Los Angeles's KDAY radio station. While on a weekend trip to Tijuana, Mexico, Mary bought me my first set of professional bongo drums. I was ecstatic. Thanks to her generosity and tolerance, I continued to play daily for about a year. During the summer of 1958, before my junior year, Mary entered me in a Bongo Contest—without my knowledge—on Cuban bandleader Perez Prado's Sunday television show on Los Angeles's KTLA, Channel 5. This led to a competition against several bongo players. Only two would appear on Prado's show as finalists. I was shocked when I was notified that I would be appearing as one of the two finalists. I competed against Jack Costanzo, arguably the best player on the West Coast. The grand prize was a one-week, all-expenses-paid trip to Mexico City. I lost. However, I considered it an honor to have been picked as a finalist. This lucky event gave my self-confidence a huge boost. The television appearance led to an invitation for me to play in Redondo Union High School's yearly Variety Show and later at the Iconoclast, a beatnik coffeehouse in Hermosa Beach.

My junior year brought a surprise and major changes that would significantly affect my assimilation. This was the year I met my first girlfriend at the Hideout. The Hideout was a place where different groups from Redondo Union High School gathered on Friday nights. The three main

groups were the Soshes (pronounced so-shez), as in highly socialized, the Lowriders and the Surfers.

Soshes were the highly visible, popular students who were always involved in multiple school activities and organizations. This included some of the brainier students. They were mostly Anglo, with an infinitesimal number of Mexican Americans scattered among them. Dress for Sosh boys was button-down collar shirts and polished cotton pants with a small silver buckle sewn below the beltline between the two rear pockets. Levis were also very popular. Oxford shoes were sometimes worn with colorful Angora wool socks, which often had ornate designs such as champagne glasses or pairs of dice. Black Converse tennis shoes were also an option. (Sidenote: Dick Smothers of the Smothers Brothers comedy team, who attended Redondo Union High School in 1955, had arguably the largest collection of colorful Angora socks at the school.) Sosh athletes wore their hair in short crew cuts or parted on the side.

Lowriders, on the other hand, were mainly Mexican American, with a few Anglos sprinkled in, and for some unexplained reason, the surfers called them "Hodads." They wore tan or gray Khaki pants with tiny cuffs, long-sleeved Sir Guy shirts and highly polished black, square-toed Florsheim shoes. Hair was worn long and combed straight back. Lowriders got their name from the older, lowered, well-maintained Chevrolets they often drove.

Surfers were almost exclusively Anglo. Daily dress for them was Levis, white Penney's T-shirts or long-sleeve Pendleton wool shirts and white or black Converse tennis shoes. Their hair was worn longer and was often partially bleached. They frequently showed up at morning classes with wet hair from surfing before school.

Despite some differences among these groups, they all came together at the Hideout. Joining the three groups were a few independents who didn't belong to any particular group. The Hideout was best described as a socially neutral zone where the different groups met to socialize and dance. It was aptly named because it was below ground level and had subtle lighting so that students could mingle and dance without being conspicuous. It was off campus, away from teachers and school administration, and was operated by the City of Redondo Beach's Recreation Department, which made it an independent location where students could enjoy each other's company, be themselves and break away from some of the artificial social pressures of school. Students could temporarily escape from watchful and biased parents for one night of the week. Music was provided by the official Hideout disc jockey, Ronnie Serrato, who played the single 45-RPM records of the day by top '50s artists like The Platters, The Penguins, Little Richard, The Everly

Brothers and Elvis Presley. He instinctively knew the best records to play to set the mood for even the most timid to dance. Today, he remains the most popular oldies DJ in the South Bay.

The Hideout became important to me because there I could transition among all of the different social groups—and it is where I met "Miss B," my first girlfriend. By this time, my circle of friends had grown to include a mix of male and female, Soshes, Lowriders, Surfers and Independents. I still remained loyal to my friends from my neighborhood, but I no longer had exclusive friendships with them or with any group. For example, the night I met Miss B at the Hideout, I was with Anglo, Mexican American, Sosh and Surfer friends. She was with her best friends, Erin and Coleen. Surprisingly, despite our differences, Miss B and I seemed to have a mutual attraction toward one another. After meeting her, I recognized that if there were going to be a relationship between us, both our worlds would have to change. I was Mexican American, and she was a song leader. For her, there was the problem of dealing with her Sosh friends, who would probably not understand how two people so different could come together. A probable and valid question from both her friends and mine would have been, "What could these two people possibly have in common?" I could only answer that question by saying that often, opposites attract. She was unusually attractive, intelligent, impeccably dressed and an excellent student. I was a C student, somewhat brash and smug, with a sarcastic sense of humor, a memory for names, a reasonably good vocabulary, almost no Spanish accent—and I had grown a few more inches. Having almost no Spanish accent was extremely important for me to try getting past her parents when I called her at home. We started seeing each other at school, as well as after school at the Hideout.

By the end of my junior year, Miss B and I were considered a couple at school. We would double "date" on weekends with her friend Erin and my friend Steve in Steve's dad's borrowed car. ("Date" will be explained later.) Almost daily, I was teased and mocked by my neighborhood friends while we walked to school because of the way I started dressing after meeting Miss B. They would call me "Tennis Shoe Ernie" because I had replaced my shiny Florsheims with black Converse tennis shoes. "Cowboy" and "Wrangler" were other favorite nicknames, as I was now wearing Levis. I had even changed my haircut to a semi-flattop like that of my friend Gary. They would also call me Chicano Surfer. (Chicano was an insider term used only by Mexican Americans to refer to each other.) Their words stung. I was chided for being a sellout in order to fit in with my Anglo girlfriend's social circle. The ultimate insult was that I had abandoned my Mexican American

culture. These remarks were painful and hard to bear. I felt that I was at a crossroads where I had to make some difficult decisions about what direction I wanted my life to take. Several questions confronted me that required answers: Should I cave in to the peer pressure and taunts? Should I return to the comfort of my old neighborhood lifestyle? Or should I continue on my current path to assimilation? The reality of my situation was that if I gave in to my neighborhood friends' peer pressure, I would fail in my effort to make independent decisions on my own and to chart my own course. After weeks of putting up with the aggravation, I decided to continue to dress differently but still try to remain friends. If I gave in to the pressure, it would be extremely awkward wearing my old style of dress when my girlfriend and everyone else would be wearing Sosh- or Surfer-style clothing. Enduring my friends' taunts and not caving in to the peer pressure was unquestionably the hardest bridge I had to cross on my road to assimilation at Redondo Union High School. My old friends never realized how close I came to capitulating. I suspect they reluctantly understood the decision I made to continue my relationship with Miss B and her world. In the end, despite the taunts and changes, I retained my old neighborhood friendships, which continued even after I moved from Redondo Beach as an adult.

Friendships at school continued to develop both because of my relationship with Miss B and my own commitment to reaching out to others. I found that socializing and making friends was becoming natural and easy for me. My friends included students from different parts of the student body; the auto, machine, and wood shop classes; and guys from my past gym classes. This increased my sense of independence as well as my feelings of inclusion and self-confidence. I was beginning to look at my old lifestyle in the rearview mirror. It felt like I was moving on to a more inclusive and balanced sense of social assimilation. There was, however, one major social problem: dealing with Miss B's stepfather.

From the beginning, Miss B clearly told me that her stepfather was adamantly opposed to our dating. Her mother was a little more tolerant, but anything she might have said or thought was overshadowed by the stepfather's ethnic bias. Whenever I called on the telephone and he knew it was me calling, he would tell me that his stepdaughter wasn't home, even though I could hear her voice in the background. On other occasions after answering the phone, he would leave the phone dangling without telling her that I was calling. I sometimes heard him mockingly say, "Your Mexican is calling." Her stepfather never allowed me to come to her door—period. On weekends when we double "dated" with our friends Erin and Steve, they

would have to leave me at the end of her block, where I waited until they picked her up at her door and then return to retrieve me. This pattern was reversed at the end of the evening. For her birthday one year, I bought her a pink faux fur rug that her stepfather told her she could not keep. After my senior year, when I had my own car, I would park across the street from her house to pick her up for "dates." Technically, I was not going to her door, but her stepfather understood that I was circumventing his rule. His answer to my defiance was to go into his garage, turn on his car's spotlight and flash it across my face while I sat in my car waiting for her, listening to him singing derisive songs about Mexicans. He once told her, "A dumb Mexican who will never amount to anything will never date my stepdaughter." This situation remained unchanged for several years, even after she had moved out of her home. Eventually, Miss B moved to Hawaii with a girlfriend, and I entered the military. We both moved on. This experience convinced me that despite the positive relations we enjoyed at school with classmates, ethnic prejudice among parents was still alive and well. Around 1976, in a twist of irony and strictly by chance, I ran into her stepfather while doing my banking. I had graduated from college by this time and was wearing my standard work uniform of a suit and tie. As he left the teller's window, he saw me. I smiled at him and waved as he hurriedly left the bank.

My Senior Year: The Final Stretch

By 1958–59, my senior year in high school, I felt as though I had transitioned into a different lifestyle. I had spent the last three years trying to figure out the assimilation game. But my transition into full assimilation was not complete. There were still some unexpected events that would round out my last year of high school.

One day, while sitting outside the school library with Miss B, two of my old neighborhood friends stopped by to chat. As was customary at the time, we spoke English with a mix of Spanish. Apparently, a teacher walking by heard our conversation and reported it to Mr. Walden, the men's dean. I was summoned to his office, where he told me that if I continued speaking Spanish on campus, I would be expelled. God knows how I came up with this response, but I said the following: "Mr. Walden, if you expel me from school, within two days, I will have an attorney on campus to file a lawsuit against the

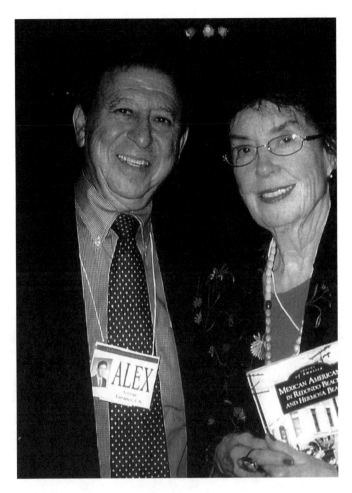

In 2009, at his fifty-year high school reunion, the author thanked Dr. Patricia Jersin, his high school speech teacher, by presenting her a copy of his first book, *Mexican Americans in Redondo Beach and Hermosa Beach. Courtesy of Linda Areyan.*

Redondo Union High School District for violation of my constitutional right to free speech, which is guaranteed under the First Amendment of the Constitution!" He looked at me in disbelief and uttered these words: "Get the hell out of my office." I was bluffing, of course, but I made my point. To this day, I still don't know how I thought to say those words, but it worked. Perhaps it was divine intervention.

CITY OF
REDONDO BEACH, CALIFORNIA

In 2007, forty-eight years after being told by his high school vice-principal that he could not speak Spanish at school, the author was given a civic award by Redondo Beach mayor Michael A. Gin and the Redondo Beach City Council for his contribution to the formerly invisible Mexican American communities of Redondo and Hermosa Beach. Despite the award, the author continues to assimilate. *Courtesy of Alex Moreno Areyan.*

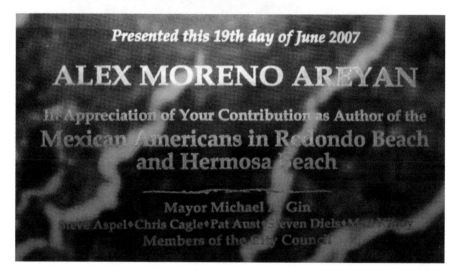

Presented this 19th day of June 2007

ALEX MORENO AREYAN

In Appreciation of Your Contribution as Author of the
Mexican Americans in Redondo Beach
and Hermosa Beach

Mayor Michael A. Gin

Steve Aspel • Chris Cagle • Pat Aust • Steven Diels • M.
Members of the City Council

A key moment of my senior year was when my remarkable speech teacher, Miss Patricia Jersin, asked me to try out for the role of Passepartout in *Around the World in Eighty Days*, the school's senior play. I think she asked me to try out because of my outgoing conduct in her class. Initially, I chuckled to myself when she asked me to come to rehearsals, and I declined. However, out of curiosity, I decided to attend the rehearsal with two of my neighborhood friends. We went to the school auditorium prepared to do some good-natured heckling of the drama students. When the person who was to play

the part of Passepartout apparently did not show up, Miss Jersin saw me sitting in one of the front-row seats and asked me to come on stage to fill in temporarily. The next thing I knew, I was memorizing lines. My friends left, and I was stuck, afraid to say anything negative to Miss Jersin, especially since I had not yet received my final grade in her class. The play turned out to be very successful and well attended. At the close of the play, the school newspaper wrote a positive review that included a front-page photo of the cast. I had gone to the tryouts to laugh at the drama students, but I ended up having an experience that changed my life. Having a major role in the senior play made me feel as if my dreams of full assimilation had been achieved. Many years later, at my 2009 high school reunion, Dr. Jersin, who went on to earn her doctorate, was our guest of honor. I was finally able to thank her for helping me change my life. My gift to her was a copy of my first book, *Mexican Americans in Redondo Beach and Hermosa Beach*, which is the first-ever pictorial history of the contributions made by Mexican Americans to both beach communities.

The last unexpected assimilation event of my high school career was being voted to be on the school's Coed Ball Court, the school's biggest social event of my senior year. Margie Hart was my date. This occasion proved that although I had struggled through self-doubt and ethnic prejudice, in the end, after four long years, I had successfully broken through the barriers of social assimilation at Redondo Union High School.

Many years later, in June 2007, forty-eight years after my encounter with Mr. Walden, I had a new experience that made me feel as if I had reached another plateau of social assimilation in Redondo Beach. At a Redondo Beach City Council meeting, I received a Civic Award plaque from Mayor Mike Gin and the city council for my contribution as the author of *Mexican Americans in Redondo Beach and Hermosa Beach*.

CHAPTER 8

COLLEGE—FIRST IN MY FAMILY!

After graduating from Redondo Union High School in 1959, I did what all my friends did: hung out at the beach at either Second Street in Hermosa Beach or Avenue C in Redondo Beach. Life was good. The summer was spent bodysurfing, tanning (I was the exception), talking to the girls and deciding where the next party would be.

Suddenly, with summer's end only about three weeks away, for the second time in my life I heard someone mention the word "college." In Palos Verdes, it had been a nebulous term that I was sure did not apply to me, but now the word "college" became real. Most of my friends said they were planning to attend El Camino College, the local community college located in nearby Torrance. When I heard the word "college," I was suddenly scared and went into a silent, mental panic. Dozens of questions arose in my immature brain. I thought back to my graduation from eighth grade at Hillcrest Junior High and the loss of those friends. Would this be a repeat of that experience? What was I going to do now? Who would I hang out with after the summer? What was this college thing all about? To make things worse, I had not even held a part-time job during high school, so how was I going to find work without any experience or family connections?

The only thing I remember hearing from my friends in the fading days of summer was that college cost a lot of money—you had to buy your books and pay this thing called "tuition." How could I or my family afford this? I also heard some of my brainier friends say that they were going away to school and that their parents would pay for everything.

Perhaps most importantly, you had to be smart to attend college. That left me out.

Who could I talk to about this college thing? No one in my family had ever attended college. My two youngest sisters, with whom I was close, unfortunately did not have the opportunity to go to college. They graduated from high school and immediately started working. I could have asked my friends a lot of questions, but I didn't want to appear stupid and uncool. My pride prevented me from admitting that I didn't have the vaguest notion about what attending college meant. Without saying anything to them or anyone in my family, I said to myself, "The hell with it—I'm going to try it."

In the fall of 1959, I entered the cavernous men's gymnasium at El Camino College along with hundreds of other students who seemed like they knew what they were doing, and I attempted to enroll in college. I was totally intimidated and did not want to be there. I had seen several of my friends standing in lines and assumed that if I needed help, one of them would help me. This was a naïve assumption. The entire perimeter of the gym was lined with dozen of tables holding forms and information sheets that made absolutely no sense to me. The registration packet contained about a dozen documents, including a batch of keypunch cards, a booklet with the days and times of classes and locations on a campus I had never visited. To say I was overwhelmed and confused is a gross understatement. This was probably the most frustrating day of my entire college experience. Since this was the first time I had seen keypunch cards, schedules of classes and all the accompanying paperwork, I had to ask several registration clerks to explain how all of this came together. The response I got was, "Just follow the instructions." I sat on the gym floor for what seemed like hours. Each time I submitted my paperwork, I was told it was wrong or incomplete and that I had to redo it. At around 2:00 p.m., I finally saw one of my beach "friends" named Fred walking out of the gym and asked him for help. He responded, "I don't have time. You just have to figure it out on your own." I said, "---- it" and was about to walk out. Almost miraculously, a clerk, who must have had pity on me after seeing me there all afternoon, helped me register for four classes—classes that I had little interest in and would not have chosen on my own. However, I felt lucky to have survived the ordeal. I became the first in my family to attend college. Twenty-five years later at my high school reunion, I saw Fred and asked him if he remembered that fateful afternoon in the fall of 1959. He pleaded ignorance. I told him how I felt that day.

Between 1959 and 1961, I was placed on academic probation twice at El Camino College and told by a counselor to leave. My academic adversary was American history. In 1962, I petitioned and was granted an exception to re-register. Again I was placed on academic probation and asked to leave. This time I was interviewed by a counselor named Dr. Wilson. He candidly told me that I did not have what it took to succeed in college. He said that my college admission test results showed that I had strong manual and finger dexterity skills and offered to refer me to a friend who hired assembly line workers at the General Motors assembly plant in the San Fernando Valley. His last words of counsel were, "I have a son like you. He would also like to graduate from college, but he'll never make it either." He added, "You're really wasting the taxpayer's money and your time by being here." His final comment was that if I ever decided to return in the future, I should take a psychology class to help me figure out if my academic problems were due to my heredity or my environment growing up. I left El Camino College feeling like a complete failure. This is when I began to wonder if my sporadic early schooling during those migrant farm-working years had somehow affected my ability to be a good student.

My next move after El Camino College was working at a medical electronics firm where my best friend, Tony Aguilar, worked and was able to get me a job. His manager, Joe Yee, turned out to be my unintended mentor. After working there about a year, with a great deal of confidence and naïveté, I asked him to consider me for a position in the medical sales department. He responded that in order to do that job, I needed a college degree. He did tell me that he would consider me for a better position but that I would have to commit to staying with the company for at least three years. The other option he presented was that if I got serious about my education, I should return to college, and if I came back, he would place me in medical sales. I continued to diligently work at my shipping and receiving clerk job while saving my money. I then impulsively decided I needed something positive in my life, and I bought a used 1961 Corvette. My rationale was that if I couldn't succeed in college and I couldn't get in to medical sales, I might as well have some fun by buying my dream car.

During the summer of 1964, I came to the point of recognizing four important things in my life. One, I was twenty-three years of age. Two, I had registered for the draft when I turned eighteen. Three, I was a prime candidate for the draft, as the United States was beginning its involvement in Vietnam. Four, going back to college was not an option for me. My impulsive response was to join the Army Reserves to preclude being drafted.

In October 1964, I reported to Fort Ord, California, for basic training. Unbelievably, this was my first time away from my family for longer than a few days, and I was miserable. Twice while in basic training, I was called into the military testing office and offered an opportunity to go to flight school to become a helicopter pilot, provided I agreed to re-enlist for three years after basic. As glamorous as it sounded, my instincts told me to say no. By 1967, the life expectancy of helicopter pilots in Vietnam was about fifteen minutes. If I had taken the offer, I probably would have become one of those statistics.

After my basic training, I was scheduled to report to radio school at Fort Gordon, Georgia, but because all of the training classes were full, I was instead assigned to Fort Irwin, California, to complete my six months of reservist training. Somehow, the army had made a mistake, and my training was extended to nine months. The only thing I learned at Fort Irwin was how to run errands for the non-commissioned officers, paint teletypewriters and sweep floors. Fort Irwin was located north of Barstow and is still the only desert training center in the country for the U.S. Army. At the beginning of the road connecting Barstow and Fort Irwin, there is a small sign that reads, "Not a Through Street." The two-lane road dead-ends forty-five miles later at Fort Irwin. This outpost consists of thousands upon thousands of desert sand dunes, scorpions and sidewinder rattlesnakes. Every morning, I shook out my boots to get rid of any wayward scorpions, and sometimes sidewinders would crawl under the barracks door to escape the cold desert nights. I had little in common with the regular army soldiers, most of whom were serving three-year enlistments. Their only source of recreation was the post's beer bar, where you could get drunk on forty-five-cent beers. Many would return to the barracks late at night, sometimes singing and waking those of us who chose to remain sober. Letters from home or from anyone were better than gold. The only letter I did not welcome was a "Dear John" letter from my old girlfriend, who had gone to Hawaii and found someone new.

It was at Fort Irwin in the summer of 1965 that I had an epiphany. I was twenty-four years old. Somehow, the words of my old boss, Joe Yee, about getting serious about going back to school to earn a degree began to resonate. One night, as I thought long and hard about where I was and the fact my enlistment had been extended to nine months, I asked myself, "What the hell am I doing here?" The next afternoon, before going to the mess hall, I wrote an impassioned letter to El Camino College, asking for one last chance to return as a student. Since it had been several years since I

had last darkened their doorstep, I explained that having spent some time in the military might have made a difference. Much to my surprise, the school allowed me to return—with conditions. First, I would have to return to my old favorite: academic probation. I would have to pass both History 15-A and History 15-B with a grade of A to make up for my past Fs in history. If I succeeded, I would be allowed to register for four classes in the fall, and they would do a grade check every two weeks. As an unexpected bonus, the army gave me an early out because I was returning to school.

In the fall of 1965, I re-enrolled at El Camino College as a probationary student. I was scared out of my wits. If I failed this time, the education game was over. I was twenty-four years old, and I would be attending school with eighteen-year-olds. I was desperate but determined. On Mondays and Wednesdays, I attended history classes at El Camino College during the day. On Tuesday and Thursday evenings, I took the same classes at Redondo Adult School, where the teacher taught in a less intimidating environment. I was getting a double dose of the same history classes four days a week. It worked.

By this time, my parents had moved from Redondo Beach and had purchased a tract home in Torrance near the college. This had been highly stressful for us, since we had left our deep roots in North Redondo, leaving family and friends behind. At school, I spent every waking hour in the library, breaking only for meals at home. I had to discipline myself to do something I had never learned to do while attending school or picking crops: study.

That year, during countless hours in the library, I learned about a man named Cesar Chavez, who had recently started to organize migrant farmworkers and who would eventually form the first-ever agricultural workers' union in the United States. Since I had been a farmworker, I immediately connected with everything he represented. Armed with only an eighth-grade education and a vision, Chavez had taken up a cause that had never been attempted by anyone. Here was a person who spoke to me. He had been a farmworker like me. He inspired and moved me like no one had ever done in my life. I felt a personal and moral obligation to support him and the workers who were still toiling in the fields. I would honor Chavez and his work by staying in school and graduating so that I could live the dream of *Sí, se Puede* (Yes, it can be done). I was hooked.

Cesar Chavez made me rethink my years of trying to assimilate into the majority culture and taught me to be proud of my Mexican American heritage. I began supporting Chavez by donating twenty-five dollars to his cause from my part-time job and my Army Reserve pay when I could afford

it. In late 1965, I met with Winnie Arballo, Chavez's coordinator of United Farm Workers (UFW) merchandise in Los Angeles, and I persuaded him to sell me his personal UFW belt buckle for a donation. I still have the buckle together with a collection of UFW pins and flags. I returned to El Camino College with a collection of buttons that I passed out to other students.

One evening during a break from studying in the library, I met an exceptional student named Ginny Yegsigian, who became one of my best friends and helped change my life. Ginny was of Armenian heritage and was extremely proud of her ancestry. She asked me if my last name was Armenian. My response was that as much as I would have liked sharing her ancestry, I was proudly Mexican American. After several discussions about ethnicity and culture during our study breaks, Ginny's friendship strengthened what I had learned from Chavez. Prior to this time, I had tried passing for Greek, Italian, Middle Eastern or whatever ethnicity would get me an attractive date. I even managed to date a Turkish exchange student when she thought I might be of Middle Eastern origin. Now, I made a promise with Ginny that we would always be open about our ethnicity in a proud and dignified manner. As I began to more fully embrace my Mexican American identity, Ginny supported me unconditionally, and she also supported Cesar Chavez and his cause. Soon, she had an army of her friends and sorority sisters supporting the farmworkers.

Ginny introduced me to her good friend Nolan Noble, who was the head yell leader at El Camino College. A couple of weeks later, he invited me to attend one of the practice sessions as a way to get me out of the library. On that day, one of the male members of the squad failed to show up for practice. Nolan asked if I would fill in on a routine requiring five yell leaders. That year, as a result of a total fluke, I became the first twenty-six-year-old Mexican American yell leader at El Camino College.

The following spring, Ginny and her friends convinced me to run for the office of sophomore class president for the 1966–67 school year, and I was elected. Walking into Murdock Stadium for the graduation ceremony in June 1967 was one of the proudest moments I had ever experienced. My greatest source of pride was that my father, who could not read or write; my mother, who went only as far as fifth grade; and my grandfather, Domingo Moreno, were sitting in the front row of the stadium as I led my class into the stadium to graduate. Lupe Zavala and I were the only Mexican Americans graduating that year.

I was no longer as anxious as I once had been about assimilating into the dominant culture. Instead, I became more focused on my evolving sense of

being Mexican American. I grew to appreciate both cultures. I was tempted to revisit Dr. Wilson's counseling office to let him know his assumptions had been wrong. Instead, I elected to move along with my life, hoping he would never succeed in screwing up another Mexican American student's life like he almost did mine.

The next stop in my unorthodox educational journey after El Camino was California State University, Long Beach (Long Beach State), in the fall of 1967. The anxiety and fear of now attending a full-fledged university was nearly overwhelming. At El Camino, I had finally found myself as a student. I had learned the critical skill of studying, had maintained above average grades, had made many friends and had even developed strong relationships with some teachers and administrators. I hated leaving the familiarity of the El Camino environment. I had been warned that El Camino was an accelerated high school compared to Long Beach State. I had also heard the usual horror stories about professors telling students on the first day of class to look at the students on each side of them because in two or three weeks, they would not be there. One example, in the second week of my political science class, validated this threat. The professor warned the students that anyone bringing a school newspaper into class and having it open when he entered would fail the class. The following week, a student who had been reading the paper when he made the announcement returned with another newspaper. The professor began yelling at this student, telling him to get out and not return. This intimidated the daylights out of the entire class, but the professor got everyone's attention.

Adding to the intimidation of attending Long Beach State was the number of books required for each class—averaging five—coupled with extensive outside readings and library research. I was certain I wasn't going to make it, and I was having flashbacks about returning to my old nemesis: academic probation. I knew I had studied hard at El Camino, but this was brutal. I never worked so hard in my life. Everywhere I went my junior year, I carried around a large legal briefcase that weighed more than twenty pounds. It became my constant reminder of what I had to do to survive. Once again, the library became my best friend. After classes, I would immediately go to the library and study until I fell asleep. Many times, my carpool partner, Sherry Brayley, would have to come wake me up. At home, I would begin studying around 11:00 p.m. and stay at it until 5:00 or 6:00 a.m. before showering and heading out to school by 7:30 a.m. Many times, my father, who could not understand why I was studying so hard, would come into the kitchen where I was studying and offer to fix me breakfast while my mother

slept. This was his way of expressing his love and support. It was impossible for me to explain why I was studying political philosophers with odd names like Immanuel Kant, Niccolo Machiavelli or Karl Marx. It was during these times that I felt entirely alone and alienated from my parents and family.

In my senior year, in 1969, Long Beach State had about thirty-two Mexican American students out of a total enrollment of more than thirty-five thousand students. The United States Civil Rights Act had been passed in 1964, and by 1969, the campus was a cauldron of civil rights protests, marches and political activism that had begun among black students. Black activism then became the model for the Asian, Native American and Mexican American students to emulate. Mexican American student activism on campus became part of the larger Chicano Civil Rights Movement, which demanded social, political, economic, educational and cultural equality for Mexican Americans. The administration at Long Beach State was shaken by student demonstrations and was very nervous and unsure about how to respond to threats to take over administration buildings. The administration went on the defensive, and police and armed guards roamed the campus to break up demonstrations that might get out of hand. Long Beach police could be seen on rooftops, photographing and videotaping student participants. The campus had become an armed camp, and it looked as if a small civil war was about to begin.

In the midst of all this, I met a fellow Mexican American student named Fernando in a political science class. He asked me whether or not I was a Chicano. Prior to meeting him, I had only heard the term used in conversations between two Mexican American males when addressing each other. To me, the word "Chicano" was equivalent to the words "blood" or "brother," which were commonly used between black males at the time. He challenged my political awareness by asking me this question. Because I didn't know Fernando, I felt as though he had invaded my personal space. I believe he did this partly because of my last name, the way I dressed and because I spoke English without much of an accent. He insisted that, as one of the few Mexican Americans on campus and a political science major, I had a social and political responsibility to join other Chicano students in pressing the administration to create outreach programs to recruit and admit more Mexican American students and faculty to the university. He invited me to a meeting of the group called UMAS (United Mexican American Students) the following week. My immediate response was that I had only one mission on campus, and that was to stay focused on graduating. Despite my initial reticence, I later decided to accept his

invitation. He explained that UMAS held its meetings in a rented trailer on the east end of the campus, which the university had assigned to them because it was far enough away from the administration buildings and the student activity center so that any possible instances of social unrest could be easily contained by the roaming police officers.

The meeting was attended by about fifteen students—half of all the Mexican American students on campus. What I discovered, among other things, was that there was an infinitesimally small number of Chicano students who were trying to bring about changes on the large campus. I wondered how a handful of angry Mexican Americans ever hoped to garner the attention, much less the support of, the university's administration. I had seen the administration's lack of response to the demands of the African American, Native American and Asian students. Despite all of this, I joined UMAS at that first meeting, reminding myself of the growing success of Cesar Chavez in the face of tremendous obstacles.

Shortly after joining UMAS, I was distressed by some Anglo student members of the Young Republicans Club on campus. They had set up tables in front of the Student Union and were giving out free grapes to passing students. At that time, Cesar Chavez and the United Farm Workers were asking all students to support their grape boycott. Every reasonable person who witnessed this defiant act appreciated the potential for a physical confrontation, yet the administration did not assign any campus police to monitor their activity. Back at the UMAS trailer, however, police and security personnel were plentiful. Attempting to defuse this insulting challenge, I approached the Young Republicans' table and invited them to a debate about the merits of the grape boycott in the free-speech area. No one accepted. I was disappointed that none of the Young Republicans was willing to discuss the farmworker's cause from my perspective. I moved on to graduation.

When I graduated from Long Beach State University in 1969, I was filled with relief that my long and arduous journey was finally over. I thought back to when I did not even understand what the word "college" meant. Through persistence and hard work, I had succeeded in reaching what had become my most important goal. I felt that I was an example of Cesar Chavez's motto: *Si, se puede.*

LIFE AFTER COLLEGE: FINDING LOVE, FATHERHOOD AND A MASTER'S DEGREE AND BECOMING AN AUTHOR

After my college graduation, I had several jobs, including working at the University of California-Irvine and UCLA. On a fall morning in 1973, while working as the affirmative action officer in the personnel department at UCLA, I reviewed an employment application submitted by a young woman whom I had seen applying for a position with the university. We had a clerical position in our office that had been open for several weeks. When I referred this woman's application to the office manager for review, she was amused and declined the application, citing the applicant's employment record. She pointed out that this applicant had recently relocated from New York to Los Angeles after being a flight attendant and said, "No, thank you." I was persistent. I took the application to the personnel department manager, John Permentier, and asked him to give the applicant a courtesy interview. Following this interview, he went to the office manager and asked her to fill the open position with this candidate. Her name was Linda Rogers. Eventually, she became my support person in the office. About six months later, we started to date without our co-workers' knowledge. In 1974, we announced our engagement and resigned from our jobs to return to school. Linda went to UCLA to complete her bachelor's degree, and I went off to law school. In August 1975, we were married, with the office manager and many of our UCLA co-workers attending our wedding. We were married at my old home church, Our Lady of Guadalupe in Hermosa Beach. Our three children—Damian, Analisa and Ryan—were born over the next eight years, and they were

each baptized in turn at Our Lady of Guadalupe. Eventually, Linda and I became the very proud parents of three college graduates.

In 1987, I returned to school to earn a master's degree in organizational development from the University of San Francisco. I took early retirement in 2004. Since then, I have enjoyed doing some volunteer work with various youth and political organizations in East Los Angeles and the greater Los Angeles area. I have been privileged to work with outstanding Mexican American community leaders such as Rosalio Munoz, Albert Juarez, Cindy Aragon, Frank Villalobos, Ricardo Munoz, Mark Guerrero and many others while trying to give something back to the community.

The development of becoming an author after my retirement was something I never foresaw. Certainly, after my numerous bouts of academic probation due to failing history classes, no one ever would have guessed that I would turn out to be a writer of regional history books. As an author, it was my great privilege to create and have published the first pictorial history book of my Mexican American community in Redondo Beach and Hermosa Beach. I followed that first book with *Mexican Americans in Los Angeles*, which documents one hundred years of the often-overlooked contributions and accomplishments of Mexican Americans in the city of Los Angeles. This second book enabled me to continue focusing my writing on the Mexican American experience. I have written *Beach Mexican* primarily for my family, but I hope it may help other Mexican Americans, Latinos or people of any other ethnic group facing the challenges of assimilation.

I realize that some people may question my fierce determination to assimilate when I was young. My motivation stemmed from the difficulties of my childhood. My family faced ethnic discrimination because we were Mexican American, and due to lack of education and opportunity, we were forced to resort to migrant farm work. It is not surprising that I thought my life would be better if I could fully assimilate into the dominant Anglo culture. I remain a loyal, proud, bicultural American citizen, with both feet firmly planted in the two cultures into which I was born. Throughout my life, I have always kept my core values and beliefs. This is the legacy that I leave to my descendants.

You can call me a Beach Mexican.

EPILOGUE

THE ROCKY ROAD OF MY CORPORATE ASSIMILATION

When I graduated from college in 1969, I believed that, from elementary school through high school and college, I had faced and overcome many of the obstacles needed to assimilate into America's dominant Anglo culture. Assimilating had meant finally fitting in—not feeling like an outsider. This was never easy, but after sixteen years of conscious effort and work, I felt I had achieved this goal. When I joined the professional working world in 1970, it marked the beginning of my new life as a corporate animal. I found myself facing the challenges of a new type of assimilation: corporate assimilation. I would struggle with corporate assimilation for more than thirty years.

Corporate assimilation was not the same as assimilating with my peers in my neighborhood or with classmates during my educational years—it meant assimilating into the values of corporate America. My successful assimilation in the workplace depended on how well I adapted my core values to the competitive political and social environment of my workplace. It also meant acknowledging the core values of my co-workers, who were mostly Anglo professionals, and how their values differed from my own.

Core values are defined as a set of long-held enduring beliefs that remain relatively unchanged over time. My core values have always focused on the importance of qualities such as loyalty, sincerity, fairness, treating others equally and collaboration with others. In the corporate world, I had to compete with co-workers in the areas of job assignments, compensation equity, promotions and career advancement. I felt that my values differed substantially from those of my colleagues and management.

From 1970 to 2004, I worked for seven different private and public sector companies, including three major aerospace firms. Throughout my career until retirement, I was almost always the only Mexican American college graduate professional to work in the human resources department of these large companies. I knew this was true because on joining these firms, I looked around for others like me but could not find anyone. Later in my career, I would be the only Mexican American with a year of law school and a master's degree in the field of Human Resources. In order to illustrate how my core values impacted my corporate assimilation, I will provide some examples.

As a recent college graduate on my first job in 1970, I was socially aware and interested in the Mexican American civil rights movement that had started around 1964. Being one of the few Mexican Americans who had graduated from college in 1969, I wanted to give back in some manner to the Mexican American community. I admired the organizations that were working to improve access for Mexican Americans in the areas of education, economic advancement and equal employment opportunities. Despite the passing of the Civil Rights Act of 1964, opportunities for Mexican Americans were still very limited. To contribute directly to these areas was difficult for me because I was living in Redondo Beach and was geographically removed from East Los Angeles, where the majority of Mexican Americans in Los Angeles lived and where most of the civil rights activity was taking place. Despite my desire to volunteer, I had never developed direct contacts with any community leaders or organizations, and I felt that if I attempted to volunteer to help the community in East Los Angeles, I would be seen as an outsider.

In the mid-1960s and into the early 1970s, East Los Angeles community organizations were being infiltrated and investigated by the Los Angeles Police Department, the Los Angeles County Sheriff's Department and the Federal Bureau of Investigation. These government agencies believed that the Mexican American political and community organizations were being used as a pretext for demonstrations and rioting and were acting as communist fronts. Mexican American community activists were being arrested. For me, volunteering under those circumstances was dangerous and could have led to my arrest and, thus, the loss of my employment. However, I did manage to attend the Chicano Moratorium Rally in August 1970 to protest the disproportionate number of deaths among Mexican American soldiers fighting in Vietnam. Many of these young men who were drafted into the military were recently married and had started families, but they

were not exempt from the draft. Their families were left behind without military or federal programs to help fill the income gaps created by absent husbands. Wives with small children were forced to apply for welfare benefits to supplement their husbands' military pay while their husbands were fighting and dying in Southeast Asia. While these young men were being drafted, others who were not Mexican American were attending college and receiving draft deferments. The Chicano Moratorium Rally, which was the most important Mexican American civil rights protest held in Los Angeles at that time and one of the most important protests held during that time in the nation, was organized and led by Rosalio Munoz, the first Mexican American student body president of UCLA. Attending this event raised my social and political awareness to a level that caused me to want to become more involved in the Mexican American community. I felt guilty being a distant observer.

With my growing awareness, I was challenged by an incident that occurred at work in 1970, my first year after college. I had been hired by one of the largest petroleum companies in the state as a credit card collections representative. My duties involved contacting customers to collect payments on delinquent credit card accounts. Much to my surprise, in less than three months, I was recognized as the top collector for ninety consecutive days, as I had collected close to $1 million in delinquent accounts. My reward was an invitation to dinner with the top department officials at a fancy restaurant on Wilshire Boulevard and an increase in salary. I continued to be a top performer, and within a year, I was asked by management if I would be interested in a marketing department position with an eventual transfer to the company's Venezuelan oil holdings, a job that required a college degree and the ability to speak Spanish. I was flattered.

However, shortly after I received this offer, an incident occurred involving a young Mexican American female clerk from East Los Angeles who worked in the company's mail room. While eating lunch in the company cafeteria with friends, she was discussing her upcoming social activities for the weekend. As was common among second-generation Mexican Americans while speaking English, she mixed Spanish words into her conversation. An older Anglo professional who overheard the conversation said to her, "If you're going to speak that shit, go back to Mexico." After lunch, I heard her crying in her work cubicle. Concerned, I asked her why she was crying, and she hesitated to tell me why she was upset. Several minutes later, her friend, who had been with her at lunch, came to her cubicle to check on her. Both employees told me how embarrassed and humiliated they had felt

after hearing the man's comment. By the end of the day, word about this event had spread to other Mexican American clerical and custodial workers who were concerned that their right to free speech had been violated. Since I was the only Mexican American professional in the department, a group approached me and asked how they should handle the matter. I recommended that they report the incident in writing to supervision and state that a simple apology would fix the problem. Instead of correcting the problem, management threatened the employees with loss of their jobs if they pressed the matter and continued to insist on receiving an apology from the Anglo employee involved or from the company on his behalf. I was asked by the Mexican American employees if I would help them mediate the problem. I agreed to do so. I went to my immediate manager to explain the problem, and much to my surprise, I was told, "If you get involved, you could be on the outside looking in." Several months later, when the credit department was sold to a company in Atlanta, Georgia, I was offered a transfer. I declined, recognizing that the South was not a place where I wanted to live and work. Approximately six months earlier, several civil rights activists in the South had been found buried under newly constructed freeways. The job offer in Venezuela was not mentioned again. I moved on to my next two jobs, working for the University of California-Irvine and UCLA. I realized later that in this case, I had let my personal values interfere with my organizational values, which negatively affected my assimilation at that company.

At UC Irvine, I was hired as the affirmative action recruitment specialist in human resources and compensation. My task was to help the university attract ethnic minorities and women to staff positions on campus. Instead of doing this job, however, I was almost immediately assigned to a specially created position acting as liaison between the university president and the minority students on campus. The president's office was being besieged almost daily by student demonstrators marching outside, protesting the university's policies regarding the lack of minority admission programs and its failure to create outreach for minority professors on campus. Ten months later, before ever having an opportunity to assimilate into the work force there or perform the job duties that I was hired to do, I accepted an inter-campus promotional transfer with a generous salary increase, moving to UCLA to do the work I was originally hired to do at UC Irvine.

At UCLA, I was appointed the affirmative action officer for the campus, and I was responsible for recruiting and increasing the number of Mexican Americans, Native Americans, African Americans, Asian Americans and

women in staff positions across all non-teaching departments on campus. At that time, the university had about twelve thousand employees, and my job was to hire individuals for those positions who would reflect the ethnic diversity of the students on campus. I thoroughly enjoyed my work, and I planned to develop a career at UCLA for several reasons. I had a responsible position, and I enjoyed full management support while satisfying my need to make tangible social contributions by providing employment opportunities to multiple ethnic communities. Equally important to me was the fact that I met my future wife, Linda, on campus when she applied for a staff position. She later became my administrative assistant, and with her help, within a year, we were able to increase the presence of Native Americans in staff jobs from less than 0.5 percent to almost 5.0 percent, with most of the hires being women. In other departments, I increased the number of Mexican American employees from about 1.0 percent to nearly 6.0 percent. These percentages significantly enhanced UCLA's image as being socially and politically progressive in their hiring while establishing the university as an excellent place to work. Despite these positive developments, in a few campus departments, there were still some random pockets of assimilation resistance to my presence, as well as the presence of the employment candidates I was responsible for hiring.

One morning, for example, I called one of the medical school departments and introduced myself as the new employment recruiter. I asked the hiring doctor if there were any specific qualifications needed for the two clerical positions he needed to fill. His response was, "Just send me some good candidates, but don't send me any Mexicans. All they want to do is sit around drinking coffee and talk around the copy machines." I asked if he had experienced these problems with this type of employee previously. He replied, "Yes." I then suggested that we meet personally later that week to discuss his concerns. When I arrived for our appointment, I noticed that his female assistant appeared uneasy and delayed announcing my arrival. Eventually, I was escorted into his office. The look on his face was one of astonishment. After several minutes, I explained that I was the new affirmative action recruiter for the campus and reminded him that under federal law, we were required to send all applicants for positions regardless of race, age, gender or national origin. I assured him that I would do my best to send him qualified candidates. With human resources management's approval, for the next three weeks, I sent only qualified minority candidates for consideration. He hired two Mexican American females.

Paradoxically, another pocket of assimilation resistance was the university law school, located across the street from my office. Because they were fully aware of the requirements of the Civil Rights Act of 1964 prohibiting any form of discrimination, I found it surprising that they were not receptive to interviewing candidates with last names like Washington, Rodriguez, Yamasaki or Nighthorse. I referred only minority candidates for employment openings at the law school, but they did not hire any of these applicants for almost two years. They finally cancelled their job requisitions.

Despite these exceptions, I enjoyed nearly two years of incomparable assimilation experiences at UCLA while working in Murphy Hall, the university's administrative headquarters. I held a responsible and legitimate position and had the full support of all levels of management. I was able to do outreach recruitment in the multiple neighborhoods of East Los Angeles, South Gate and the San Fernando Valley. I successfully placed minority personnel in diverse university positions from groundskeepers to police officers, and I participated in oral interview review boards for the university police department. I had finally crossed over the professional assimilation bridge as a bona fide employee of the university.

After nearly two years at UCLA, I reluctantly resigned for an opportunity to attend law school. In making this difficult decision, I remembered the prediction made by my counselor at El Camino that I would never attend law school, and I decided that I could not pass up this opportunity. From a class of over one hundred first-year students, including one medical doctor, only thirty-one of us completed the first year of law school, which was one of the most difficult tasks I had ever undertaken. After a year of grueling work, I could not look forward to three more years. I made the difficult decision to move on with my life, and it turned out to be the right decision for me. I returned to Human Resources as my chosen profession.

In each of my positions, I was able to satisfy my continued interest in promoting civil rights to some degree, often by working in the field of affirmative action, providing jobs to individuals in the underserved communities of Mexican Americans and Latinos, Native Americans, African Americans and women. My positions during these years had some unspoken political restrictions that I felt prevented me from becoming more involved with overt civil rights activities even on my own time. Company politics caused me to subordinate my enthusiasm for giving back to the Chicano community. Top management did not always share my level of enthusiasm

for supporting affirmative action. However, despite this dilemma, I was able to substantially increase the number of Native American and Mexican American employees, who had not been proportionately represented in the workforces of the companies that employed me.

My assimilation continues.

BIBLIOGRAPHY

Aguilar, Leslie C. *Ouch! That Stereotype Hurts*. Flower Mound, TX: The Walk the Talk Co., 2006.

DuBois, W.E.B. *The Souls of Black Folk*. New York: Gramercy Books, 1994.

Jimenez, Francisco. *Breaking Through*. New York: Houghton Mifflin Company, 2001.

————. *The Circuit: Stories from the Life of a Migrant Child*. Boston: Houghton Mifflin Company, 1997.

Scott, Harrison Irving. *Ridge Route: The Road That United California*. Torrance, CA: Harrison Irving Scott, 2006.

Thomas, Frank P. *How to Write the Story of Your Life*. Cincinnati, OH: Writer's Digest Books, 1984.

ABOUT THE AUTHOR

Alex Moreno Areyan, a retired Human Resources administrator with a master's degree from the University of San Francisco, was a migrant worker in his youth. His two prior books, *Mexican Americans in Redondo Beach and Hermosa Beach* and *Mexican Americans in Los Angeles,* document the presence and frequently overlooked contributions of Mexican Americans who shaped the histories of these communities. In addition to writing about the many dimensions of the Mexican American experience, Areyan also enjoys international travel, reading and listening to vintage *ranchera* and *norteño* music. He resides in Torrance, California with his wife, Linda, and is the proud father of Damian, Analisa and Ryan. He and his wife are also the happy grandparents of James Michael Areyan.

Visit us at
www.historypress.net

. .

This title is also available as an e-book